micro mosaics

Angie Weston

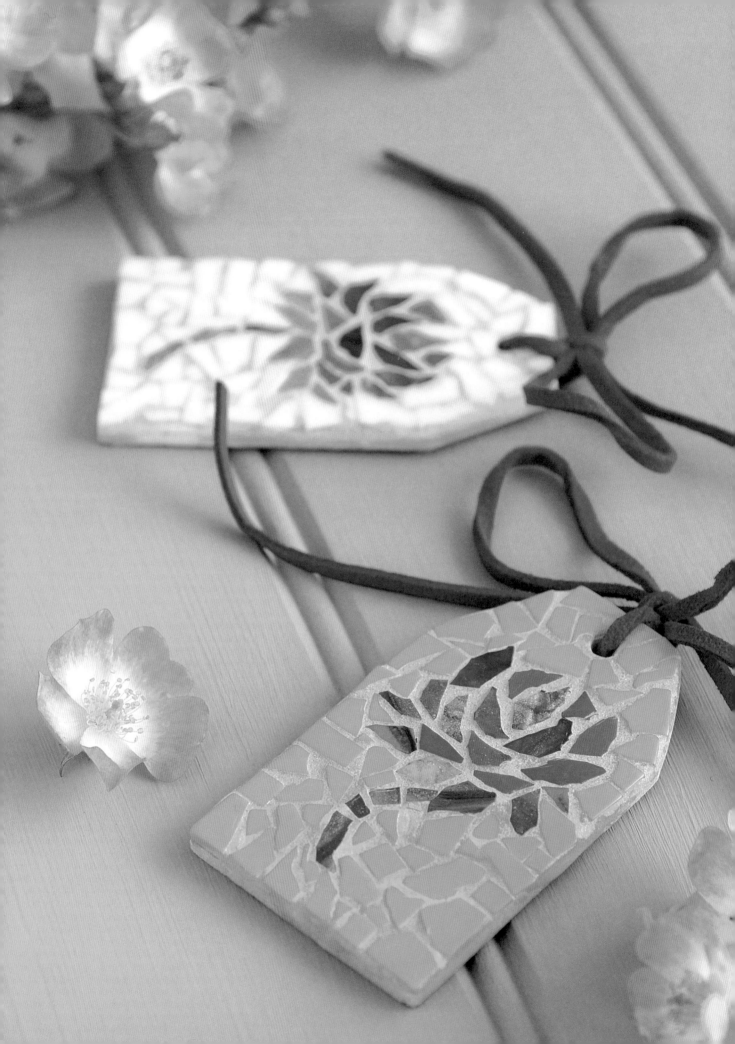

micro mosaics

Innovative mini and micro
mosaics to wear, use and carry

Angie Weston

David and Charles

www.mycraftivity.com

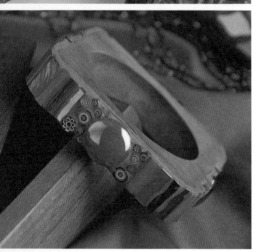

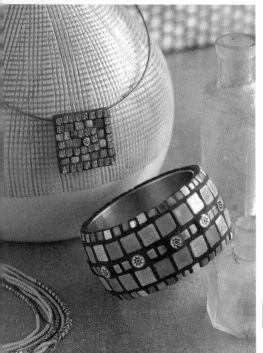

For Pete,
ma raison d'être

A DAVID & CHARLES BOOK
Copyright © David & Charles Limited 2009

David & Charles is an F+W Media Inc. company
4700 East Galbraith Road
Cincinnati, OH 45236

First published in the UK and US in 2009

Text and designs copyright © Angie Weston 2009
Layout and photography copyright © David & Charles 2009

Angie Weston has asserted her right to be identified as author
of this work in accordance with the Copyright, Designs and
Patents Act, 1988.

A catalogue record for this book is available from the
British Library.

ISBN-13: 978-0-7153-3037-1 paperback
ISBN-10: 0-7153-3037-3 paperback

Printed in China by R R Donnelley
for David & Charles
Brunel House Newton Abbot Devon

Commissioning Editor: Jane Trollope
Desk Editor: Emily Rae
Assistant Editor: Joanna Richards
Project Editor: Lin Clements
Art Editor: Sarah Underhill
Production Controller: Beverley Richardson
Photographer: Ginette Chapman

Visit our website at www.davidandcharles.co.uk

David & Charles books are available from all good bookshops;
alternatively you can contact our Orderline on 0870 9908222
or write to us at FREEPOST EX2 110, D&C Direct, Newton
Abbot, TQ12 4ZZ (no stamp required UK only); US customers
call 800-289-0963 and Canadian customers call 800-840-5220.

Contents

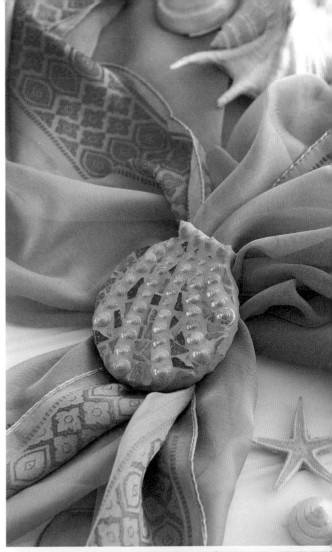

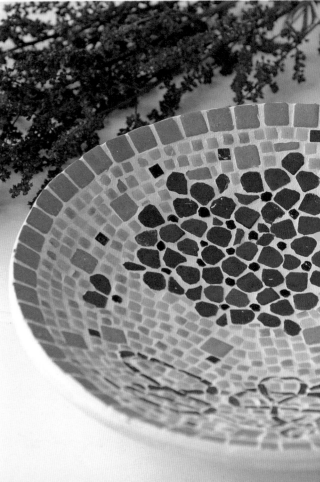

Introduction

If you enjoy mosaics and mosaic making, what could be better than being able

to create a mosaic that is small and light enough to wear or carry while still

retaining the detail and clarity in the mosaic design?

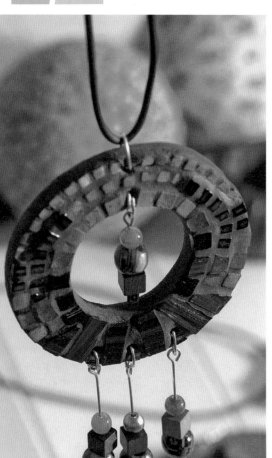

EARLY SMALL-SCALE MOSAICS

Accessories and body decorations adorned with mosaic detail of American Indian origin have been found dating as far back as the 15–16th century Mixtec/Aztec times. The British Museum has some exquisite examples from this era of turquoise mosaic masks, ceremonial attire and accessories such as decorative mosaic knife handles (see page 126 for website).

THE ART OF MICRO MOSAICS

Micro mosaic making, in which mosaics are painstakingly assembled from thousands of tiny coloured enamel rods called tesserae, is most famously associated with Rome, Italy, of the 16th century. This was when, in an attempt to preserve the longevity of its famous altar paintings from atmospheric decay, the Vatican replaced the precious artworks inside St Peter's Basilica with micro mosaics.

Although referred to as 'enamel', the exact composition of the component materials that make up the tesserae used in these micro mosaics is a well-kept secret. While they share some of the same qualities as traditional glass mosaic tesserae, they do differ from them and can have a non-reflective surface. Over a period of many years, an almost limitless number of colours and shades of these tesserae were developed that enabled the micro mosaic maker to reproduce paintings to near perfection. It is possible for a 2.5cm (1in) square space to contain up to 5,000 minute pieces of tesserae, as explained in the definitive reference book on the subject, *Micromosaics: The Gilbert Collection* by Jeanette Hanisee Gabriel. The method of laying these tesserae was refined to such a degree that to the untrained eye it is almost impossible to tell the difference between a cut tile and a brushstroke, and at normal viewing distance, many people believe that they are actually looking at a painting.

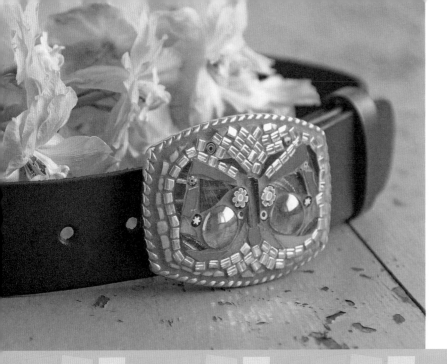

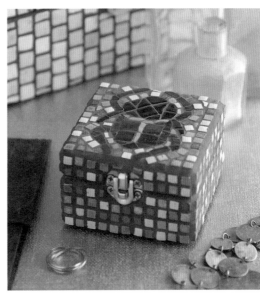

THE FIRST MOSAIC JEWELLERY

In the early 19th century workshops in Rome began to produce luxury items such as pillboxes and jewellery that were embellished with micro mosaics. These in turn became very popular with wealthy tourists, who transported them across Europe and beyond. Some of the finest examples of these micro mosaics can now be seen at the Gilbert Museum in London (see page 126 for details).

CONTEMPORARY MICRO MOSAICS

Today, modern manufacturing methods enable low-cost mass production of mini, micro and nano (tiny ceramic) mosaic tiles so that everyone can enjoy the challenge of creating a miniature mosaic and revive some of the spirit of those dedicated artists of bygone times. The projects in this book are designed to help you experiment with this fascinating and alluring art form, and to discover new ways in which to explore mosaic making on a small scale.

USING THIS BOOK

You will find a delightful collection of micro mosaic projects in this book, described in illustrated step-by-step instructions. Projects also have useful guides on the time taken to make the project, the drying times and the finished weight of jewellery items. The making times are given to help you plan a time slot for creating the pieces and will give you an indication as to whether a project is achievable in an evening or a weekend. The actual time taken to create each item will depend on your skill level and experience, so the times quoted may vary. Drying times will also vary depending on your room/air temperatire and humidity. The materials, tools and techniques you will need are described on pages 8–27.

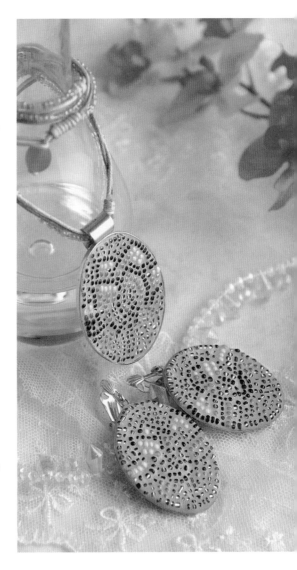

Mosaic-making Materials

All the projects in this book use a mixture of the materials shown here. In addition to traditional glass and ceramic mosaic tiles in various sizes, you will also find other mosaic materials such as resin tiles, beads and shells incorporated into the designs. Once you have gained some experience and confidence, you could expand your materials to include twisted metal wire shapes such as coils and springs, or diamante crystals, gem stones, buttons or pebbles. Note that mini tiles are sometimes referred to as 'tiny' in the United States.

VITREOUS GLASS MOSAIC TILES

Two main tile sizes are widely available: standard tile 20 x 20 x 3mm (¾ x ¾ x ⅛in) and mini tile 10 x 10 x 3mm (⅜ x ⅜ x ⅛in). These tiles, generally supplied on either fibreglass mesh or paper (which can be soaked in warm water to remove), can also be purchased loose, by weight. Standard and mini mosaic tiles are the same 3mm (⅛in) thickness, which allows for easy integration and combination with each other and with the mini and micro ceramic tiles detailed below.

Tip YOU CAN MAKE YOUR OWN MINI GLASS TILES BY SIMPLY DIVIDING ONE STANDARD TILE INTO FOUR EQUAL SQUARES (SEE PAGE 17).

Available in a wide range of colours and finishes, such as marbleized (swirled complementary and contrasting blended colours), metallic (gold/copper veining) and iridescent (opalescent, mother-of-pearl shine), stunning special effects are achieved through the addition of metal oxides and mineral salts in the production process.

CERAMIC MOSAIC TILES

These can be glazed or unglazed and are also available in a range of sizes and finishes. Standard-sized 20 x 20 x 3mm (¾ x ¾ x ⅛in) fired-clay unglazed ceramic tiles tend to be limited to a muted palette of natural stone and antique colours, whereas the mini-sized 10 x 10 x 3mm (⅜ x ⅜ x ⅛in) and micro-sized, 5 x 5 x 3mm (¼ x ¼ x ⅛in) are also widely available in a more vibrant choice of colour-glazed finish.

Tip AS WITH GLASS TILES, A STANDARD TILE CAN BE CUT INTO QUARTERS TO PRODUCE A MINI VERSION OR EIGHTHS TO PRODUCE MICRO TILES (SEE PAGE 17).

Although flatter in finish and much less vibrant than vitreous glass tiles, these ceramic tiles can be used very effectively in combination with glass to enhance the reflective qualities and vary the surface texture of a mosaic.

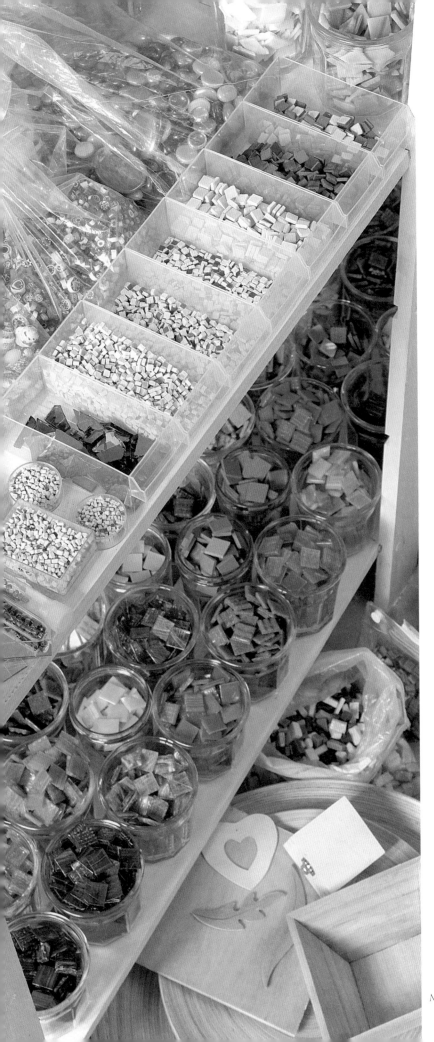

CERAMIC (NANO) TILES 3MM (1/8IN)

These tiny tiles measure 3 x 3 x 2mm (1/8 x 1/8 x 1/16in) and are smaller versions of the glazed and unglazed mini and micro tiles mentioned opposite. They are available in a limited palette of greens, blues, reds, yellows and natural stone colours. Care must be taken when combining these tiles with the larger 3mm (1/8in) thick versions, as they can become buried in the grouting process and lost at the surface.

Tip NANO TILES CAN BE USED IN COMBINATION WITH RESIN TILES (SEE BELOW), AS THEY SHARE THE SAME 2MM (1/16IN) THICKNESS.

RESIN MOSAIC TILES

These tiles are relatively new and are available in mini size 10 x 10 x 2mm (3/8 x 3/8 x 1/16in) and a micro size of 5 x 5 x 2mm (1/4 x 1/4 x 1/16in). They are available in a great choice of colours in flat matt to pearlized or metallic finishes that mimic the traditional glass tile effects.

Tip THE GREAT ADVANTAGE OF SUPER-LIGHTWEIGHT RESIN TILES IS THAT THEY CAN BE CUT WITH HOUSEHOLD SCISSORS, MAKING THEM IDEAL FOR CHILDREN AND SAFER TO USE IN CONFINED AREAS.

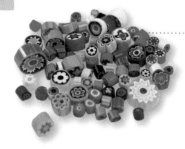

MILLEFIORI GLASS BEADS

Available opaque or transparent, these exquisite glass beads are generally sized from 4mm (1/8in) to 13mm (1/2in) in diameter, although thicknesses and diameters will vary since each bead is still handmade and handcut in Italy today, as they have been since the 15th century. Millefiori means 'thousand flowers' and refers to the motif that is created by arranging thin glass rods into bundles, which are fused together and, while still hot, stretched. The motif can only be viewed from the cross section at the end until they are cut into literally thousands of glass beads. As well as the traditional flower design, these beads are now made into a colourful array of more modern designs such as stars, hearts and swirls. Millefiori beads are generally sold by weight.

Polymer clay millefiori beads are a lightweight, cheap alternative and can be purchased through jewellery-finding suppliers (see page 126). Experienced polymer clay users who use 'canework' techniques use similar methods of production to those used in traditional millefiori glasswork.

GLASS GEM BEADS

These are available in many different colours and can be shiny, metallic, iridized or frosted. The transparency varies from completely opaque to completely transparent. It is possible to cut them into smaller pieces using wheeled tile nippers (see page 14).

MOSAIC MIRROR TILES

Mirror tiles are mounted onto flexible fabric backing sheets and can be used individually or cut into small pieces with household scissors or tile nippers (see page 14). Available in squares from 12–25mm (1/2–1in), they are

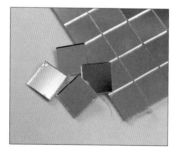

also manufactured in circular, triangular and diamond shapes.

Coloured mirror glass is also available in a great range of colours and textures. Sold in sheets or mixed bags of pre-cut shapes, they add a great extra dimension to a mosaic surface with their highly reflective qualities.

Tip MINI MIRROR TILES ARE 1.5MM (1/16IN) THICK SO NEED A DOUBLE LAYER TO LEVEL THE SURFACE HEIGHT TO THAT OF A STANDARD, MINI OR MICRO TILE SO THEY CAN BE INCORPORATED INTO A DESIGN.

SEED BEADS

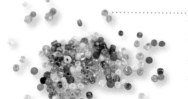

These beads are sized in 'aughts' rather than millimetres and are denoted by a slash and a zero, or a degree mark; the higher the number, the smaller the bead. The projects in this book use the most popular size 11° (11 aught), which are about 2mm (1/16in) in diameter, but once you have gained some experience with seed bead mosaics, it is possible to progress to smaller and smaller beads until you reach 24°, which are as tiny as a grain of sand. The choice of colours is endless and you can buy them with transparent, shiny or matt finishes, or with a copper, silver or bronze lining.

SQUARE BEADS

These 3mm (¹/₈in) square metallic beads are excellent for giving micro mosaics an extra sparkle. If they are the same thickness and used correctly, they can be impossible to distinguish from genuine mosaic tiles and make a excellent, cheap alternative to nano mosaic tiles (see page 9). Polished square wooden beads can also be integrated very effectively into mini and micro mosaics.

Tip WHEN USING BEADS AS TILES, KEEP THE THREAD HOLES HIDDEN BY TILING THE BEAD ON ITS SIDE. ONCE GROUTED, THE SMOOTH SIDE OF THE BEAD WILL LOOK THE SAME AS A MOSAIC TILE.

DECORATIVE BEADS

Round and shaped beads in various patterns and colours are useful for making pretty necklace strings or additional bead strands to match your mosaic, and give your mosaic jewellery a professional finish. Gather together a selection of different beads for your collection – a great way to recycle old or broken bead jewellery items into a new and exciting piece.

HOMEMADE POLYMER CLAY TILES AND BEADS

An inexpensive and unique way to add to your tile range is to create your own tesserae and millefiori beads from polymer clay. Fired in a conventional oven, this coloured clay can be blended to form marbleized effects or mixed to a specific colour. Glitter paste or varnish adds sparkle. The clay can be rolled out on a flat surface and divided up into squares or cubes, in dimensions of your choosing, before hardening to a tile-like finish.

SHELLS

Small whole shells or pieces of shell can be adhered and grouted into a mosaic in the same way as beads and tiles, and will provide an interesting addition to your mosaic material resources.

MATERIALS FOR MOSAIC BASES

PLYWOOD Lightweight and easy to cut and shape, 3mm (¹/₈in) thick plywood is an ideal base for small mosaics (see Out of Africa page 72 and Hearts and Flowers page 88). Thicker plywood is often used for jewellery box blanks and should be sealed before use (see below).

PRE-CUT MDF SHAPES Craft stores stock a huge range of pre-cut shapes and they should be sealed before use by brushing the surface all over with a solution of diluted PVA (white) glue (one part PVA/white glue to five parts water). Leave to dry completely before you commence tiling (see the Rose Luggage Tags on page 88).

READY-MADE BASES Items such as ceramic, glass and plastic pots, bamboo/wooden bowls, photo frames, boxes and chests make ideal mosaic bases. In just a few hours, ordinary, plain homeware can be transformed into unique objets d'art. When choosing an item to mosaic, select sturdy objects with aesthetically pleasing shapes that have a sound, flat surface. Selecting the right type of adhesive for the chosen base material is essential.

ADHESIVES AND GROUT

PVA (WHITE) GLUE This adhesive is inexpensive, child-friendly, non-toxic and dries to a clear finish. It is water-soluble when wet and water-fast when dry. It is a good wood sealant if diluted one part to five parts water. Used for indoor mosaics, it is great for adhering tiles to wood.

POLYURETHANE TRANSPARENT GLUE This slow-drying, non-toxic glue has no vertical slippage. It is perfect for adhering tiles to glass and plastic items. It dries watertight and flexible and is suitable for use in humid or damp conditions (see Floral Treats page 84).

SILICONE GLUE This will adhere tiles to metal bases and also to wood, glass or plastic, drying transparent and strong. It is ideal for items destined for damp conditions.

GROUT Available in ready-mixed tubs or in powdered form, grout can be pre-coloured or white, ready to be coloured with paint or pigment.

ACRYLIC PAINT AND POWDERED PIGMENT Grout can be coloured with artist's acrylic paint or powdered pigment (see pages 23–24). Water-based paints such as gouache or oil-based paints are not suitable for colouring grout.

Jewellery Findings

Standard jewellery-making findings can be purchased easily from craft and bead suppliers and are relatively inexpensive (see page 126). Anyone with previous experience of jewellery making will know that the choice of findings is endless and can be a little overwhelming at first. As a general rule, it is always best to use top-quality materials to avoid tarnishing, ensure longevity and enhance the finish of your creations. The focus of the projects in this book is on the decorative mosaic content of the items and therefore the findings used have been kept simple and unfussy so as not to detract from the mosaics. From the wide variety of findings available, you will only need the following to complete the projects.

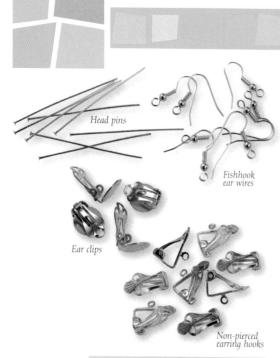

Head pins

Fishhook ear wires

Ear clips

Non-pierced earring hooks

EARRING FINDINGS

HEAD PINS (50MM/2IN)
Soft metal, blunt pins on to which beads are threaded. The end is then curled around in a loop (see technique on page 26) and attached to an ear wire or pendant.

FISHHOOK EAR WIRES
For pierced ears, these are used in combination with jump rings to attach and suspend earring bases.

NON-PIERCED EARRING HOOKS
This is the alternative for people who don't have pierced ears. The earring base is hung in exactly the same way as the fishhook ear wire above to achieve the same overall look.

EAR CLIPS OR STUDS (10MM/³/8IN)
These flat clips are glued to the back or base of the mosaic (see Mirror Stars Earrings page 40).

NECKLACE FINDINGS

SPRING ENDS (2MM/¹/16IN)
These grip the end of round thonging ready for attaching the clasp (see page 27).

LOBSTER CLASPS (12MM/½IN)
These are used to secure a necklace (see page 27), such as the Leaves Necklace on page 68.

JUMP RINGS (5MM/¼IN–9MM/³/8IN)
Used in necklaces to connect the spring end to the lobster clasp (see page 27). Jump rings are useful for hanging pendants from necklaces or connecting two findings together. When a few are linked together, they form a chain that can be used as a clasp safety chain or extension. The circular jump ring has a break so you can twist it open and closed (see page 27).

ALLERGY AWARENESS
Check with the recipient/wearer of your jewellery for skin allergies or sensitivities linked to certain metals. Many wearers will prefer sterling silver as opposed to 'silver-coloured' (nickel-plated/white tin) findings.

Jump ring

Spring ends

Lobster clasps

LEATHER CORD THONGING
(2mm/1/16in AND 3mm/1/8in)
A soft, comfortable and lightweight
contemporary alternative to chain.
It can be round or flat.
SOFT CORD (1mm/1/32in)
Used as another alternative to
chain, this can be strung with beads
and combined with other cord
for a multi-strand finish (see the
Magnolia Pendant page 31).
EXTENSION CHAINS
Used if you are not sure of the
length of the piece of thonging that
is required.
JEWELLERY WIRE
(0.2mm/0.0079in–1.5mm/1/16in)
Multi-purpose wire for looping,
coiling and threading. Available in a
wide range of colours and metals,
such as brass, copper and silver.
MEMORY WIRE
A very strong, extremely hard wire
that always returns to its original
circular shape when pulled out
of shape (see In Egyptian Mood
chapter, page 44). It is generally
silver-plated or gold-plated.
ENDCAPS
These are used to finish off memory
wire and make it comfortable to
wear, and are usually glued onto
the ends of the necklace wire using
epoxy resin glue.

KEYRING, MOBILE PHONE, MP3 PLAYER, DIGITAL CAMERA STRAPS

These are coloured cotton cord
straps, usually 1mm (1/32in), with
a crimped collar and jump ring,
which can be opened to attach your
mini-mosaic accessory.

BLANKS AND BASES

BROOCH PINS, SCARF/SARONG
CLIPS, TIE PIN CLIPS,
CUFFLINK BLANKS
These have flat metal backs ready
for gluing to your miniature mosaic.
PENDANT, EARRINGS, RING
AND BRACELET BLANK BASES
These silver-plated blank bases
are designed and manufactured
specifically for the mosaic jewellery
maker. They have a lip at the edge
to frame and enclose the mosaic
(see page 126 for suppliers).
BELT BUCKLES
These rectangular or oval-shaped
brass, chrome or pewter blanks
are ready to be decorated. Leather
belt straps are usually purchased
separately, in the desired size
(see Zodiac Belt Buckles page 100).
ACRYLIC/PLASTIC/WOODEN
BANGLES AND HAIR SLIDES
These pre-made, shaped bangles
and hair accessories are strong
and robust and can be
customized with mosaic
detail to produce unique
jewellery.

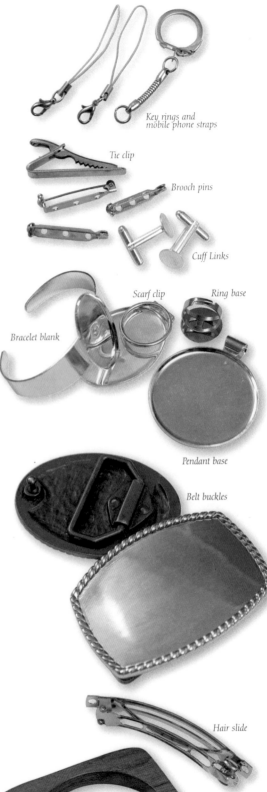

Key rings and mobile phone straps

Tie clip

Brooch pins

Cuff Links

Scarf clip

Ring base

Bracelet blank

Pendant base

Belt buckles

Hair slide

Leather thonging

Soft cords

Jewellery wires

Acrylic bangle

Wooden bangles

Extension chain

Tools and Equipment

A range of tools are needed for making the projects in this book, including specialist items such as tile cutters, pliers and drill, together with household and stationery equipment that you are likely to have already. As the following items are required for making most of the projects, they are not usually included in the specific 'You will need' lists that accompany each project.

Tungsten carbide-tipped tile nippers

Wheeled tile nippers

Tip AFTER A PROLONGED PERIOD OF CUTTING, ROTATING THE WHEELS OF WHEELED NIPPERS WILL GIVE A NEW, SHARP CUTTING EDGE AND EXTEND THE LIFE OF THE BLADES (SEE PAGE 19).

MOSAIC TILE NIPPERS

There are two types of tile nipper available to the mosaic maker.

TUNGSTEN CARBIDE-TIPPED TILE NIPPERS

Most mosaic makers will recognize these nippers, often referred to as 'sidebiter' nippers, as they are the most popular multi-purpose tile-cutting tool, ideal for cutting ceramic and glass. They are inexpensive to buy, but are less precise than wheeled nippers.

WHEELED NIPPERS

These nippers cut exact tile shapes with minimal crushing and splintering. Although more expensive than 'sidebiter' nippers, they are the preferred tile-cutting tool for professional mosaic artists. Wheeled nippers have been used throughout this book. They are supplied with an Allen wrench to rotate the blades. A spare set of replacement carbide wheels can be purchased separately (see page 19 for wheel replacement).

SAFETY EQUIPMENT

SAFETY GOGGLES

Never cut tiles without safety goggles, as flying shards of glass and ceramic can be very sharp. Goggles with extra side protection are best.

DUST MASKS

These will protect you from powdered grout dust and wood particles when cutting shapes.

RUBBER GLOVES

As cement is caustic, always wear gloves when preparing grout.

JEWELLERY-MAKING TOOLS

TWEEZERS

These are essential when working with very small mosaic tiles and beads on detailed items. They enable the micro mosaic maker to lift and place the pieces more easily and manipulate tiny elements without disturbing surrounding areas. The most effective type have a large, wide handle and narrow to a fine, very sharp point. A sharp pencil or cocktail stick (toothpick) make excellent alternatives.

Tweezers

ROUND-NOSED PLIERS

For creating wire loops for earrings (see page 26). They have conical jaws (available in various sizes) which are smaller at the tips than at the base.

FLAT-NOSED PLIERS

These have long, flat, smooth jaws that do not taper at the ends. They provide grip to open and close jump rings and to clamp clasps and ends to wire and thonging.

WIRE CUTTERS

These are absolutely essential if working with wire. Be careful never to use your cutters on wire larger or harder than the cutter is designed for, as this will damage them beyond use. Blunt cutters leave a jagged edge on jewellery that is uncomfortable for the wearer. Wire cutters are ideal for cutting head pins (see page 26). Memory wire (see page 13), made from hardened steel, requires heavy-duty cutters.

GROUTING EQUIPMENT

PALETTE KNIVES

Pointed and rounded palette knives help to press grout into awkward gaps and embed beads more easily.

GLASS JARS/GROUT TRAYS AND PLASTIC CONTAINERS

Needed for mixing grout. Plastic drinks bottles make excellent grout-mixing containers. Recycle used bottles by cutting them in half to make two disposable pots in which to mix grout.

SPONGES, CLOTHS AND HOUSEHOLD FURNITURE POLISH

For cleaning and polishing the finished mosaics.

SCALES AND MEASURING JUG

Used to ensure correct quantities when mixing powdered grout and water (see page 23). Keep such equipment solely for this purpose.

PAINTS AND PIGMENTS

Used to colour grout – see page 22.

BASIC STATIONERY ITEMS

TRACING PAPER

For transferring a design from a template (see technique page 110).

PENCILS, COLOURING/WAX CRAYONS AND SKETCH BOOK

For designing and tracing mosaics and sketching motifs onto bases. Use soft pencils such as 2B and 4B.

MARKER PENS

For drawing designs onto plastic, metal and ceramic bases.

SCISSORS AND CRAFT KNIFE

For cutting resin tiles, thonging, cord and sticky-backed felt.

RULER/TAPE MEASURE

For designing and measuring.

PAINTBRUSHES

Various sizes are required for painting and gluing.

WOODWORKING TOOLS AND ACCESSORIES

DRILL, DRILL BITS, SCREWDRIVER AND SCREWS

Needed for fixings and hangings.

JIGSAW, SCROLL AND WOOD SAW

To cut wood shapes and base boards.

AWL OR GIMLET

Used for boring into wood to position fixings.

D-HOOKS, SELF-TAPPING EYELETS, METAL FIXING PLATES AND CLIPS

For finishing and hanging mosaics.

SANDPAPER

For smoothing and tidying grout edges and removing splinters from sawn edges of wooden base shapes.

Flat-nosed
pliers

Wire
cutters

Round-nosed
pliers

Techniques

This section describes the core techniques involved in the projects in this book, including how to cut mosaic tiles into various shapes, basic mosaic design principles, methods of laying tiles, how to mix and colour grout, how to grout a mosaic and the essentials of jewellery making.

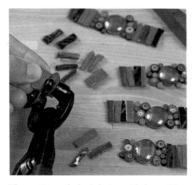

The precision of wheeled nipper blades enables thin lines of tile to be cut very accurately, so specific shapes can be formed easily.

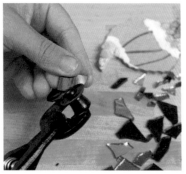

All types of mosaic materials can be cut using wheeled nippers, from mirror pieces to glass gem beads.

TILE CUTTING AND SHAPING

The technique for using wheeled nippers varies slightly from that of the classic 'sidebiter' nipper. As with all mosaic-cutting tools, it is best to hold the handles of the nippers as near to the end as possible to allow the spring to make the most effort. Unlike the 'sidebiter' nipper, where the nipper can be rotated to use both the rounded and flat edges of the cutting jaws and the tiles placed either side of the nipper cutting edge, wheeled nippers must be held with the wheels positioned inwards towards the tile. While the cutting edge of the 'sidebiter' nipper is to one side of the jaws, the wheeled nipper closes around the tile, allowing for the removal of fine points and very accurate small pieces. The jaws close to their tightest cut in the centre where the wheels meet.

If you are unfamiliar with using this type of nipper, before you start cutting, try opening and closing the nippers and observing the clenching action and position of the blades.

With all tiles, the closer to the edge you nip, the easier it is to break the tiles and make an accurate fracture. The action should be gentle and the motion swift and firm, with even pressure. If you are tense or having to work hard to cut the tile, simply release the jaws and start again. The more practice and experience you gain, the more accurate your cutting and shaping will become. With wheeled nippers, most tiles will break in the way you intend, but inevitably some will fracture differently. It is important to enjoy all the accidental and unintentional shapes that are created in the process and it is a good idea to keep a pot of these pieces, which can be used later in a different project or in another design.

Tip WITH MINI AND MICRO MOSAICS, IT IS OFTEN POSSIBLE TO CUT REJECTED PIECES OF TILE AGAIN INTO SMALLER DESIRED SHAPES.

CUTTING SQUARES AND RECTANGLES

This technique is the same for both ceramic and glass tiles. Mirror and resin tiles can also be cut in the same way.

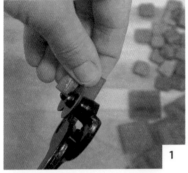

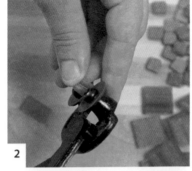

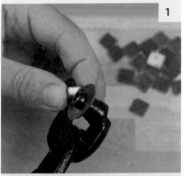

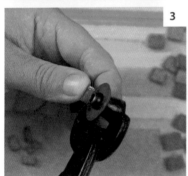

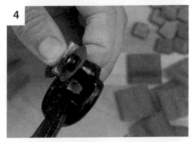

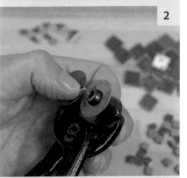

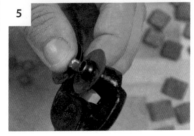

1 Hold the tile firmly between thumb and index finger above the nippers and place it into the wheels so that the bottom edge of the tile is aligned in the centre of the two blades. Squeeze the handles of the tile nippers together in order to 'nip' the tile and cut it in half.

2 To divide the tile into quarters and create mini tiles, take one of the rectangles and turn it 90 degrees so that it is again in the centre of the blades, as shown in picture 2.

3 Repeating this process will divide the mini tile into eighths or micro tiles.

4 The same positioning of the tile in relation to the nipper is also used to divide tiles into thirds or sixths. These rectangular shapes are ideal for creating lines in a mosaic.

5 The smaller the pieces, the more difficult it is to keep a firm hold of the tile. With mini and micro tiles, place your thumb and finger on either side of the wheels, as shown, to avoid pinching or trapping your fingers in the cutting blades. When the pieces are small, the cut is made in the centre of the tile, rather than at the edge.

1 Hold the tile as shown in a diamond formation, with the point plunged down into the centre of the cutting wheels. Repeat the process to create smaller triangles.

2 To remove a small point or corner from a tile, place the point to be removed into the nippers, holding the rest of the tile firmly alongside the wheels, as shown.

CUTTING OVAL AND CIRCULAR SHAPES

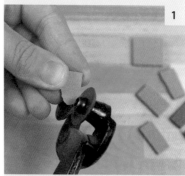

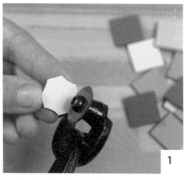
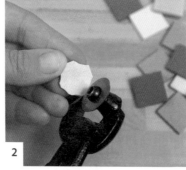

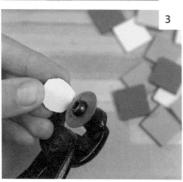
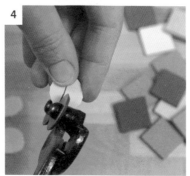

1 2

3 4

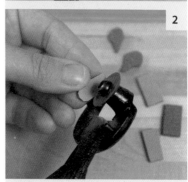

1 To shape curves, it is best to cut away small pieces at a time. As the nippers are very precise, start by removing the four corners, leaving an octogon shape.

2 Now begin to remove the remaining angles or points by 'nibbling' the edges. You will start to hear a grinding sound as you rotate the tile evenly, moving it through your fingers.

Tip TO GET THE MOST USE OUT OF YOUR WHEELED NIPPERS, USE A PERMANENT MARKER TO MARK A LINE ON THE WHEELS WHERE YOU FIRST USE THEM TO CUT. AS YOU ROTATE THE WHEELS, YOU WILL EVENTUALLY RETURN TO THE MARK, INDICATING THAT IT IS TIME TO CHANGE THEM FOR A NEW SET.

3 Nip very fine pieces from the edge to complete the curve or arc. Cutting circles requires an even nipping and turning action.

4 If you remove too much material from one side of the circle, you will have to compensate all the way round, which will lead to a reduced diameter. If you accidentally nip too much, make a straight cut across the bottom and turn it into a neat semicircular shape or cut an equivalent amount from the opposite side to form an oval shape.

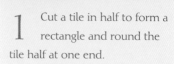

1 Cut a tile in half to form a rectangle and round the tile half at one end.

2 Make one straight-angled cut from the new edge of the curve to the centre of the straight bottom edge, as shown.

3 Make a second angled cut to meet the first straight-angled cut in a point at the bottom and the edge of the curve at the top.

CUTTING LEAF SHAPES

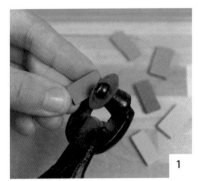 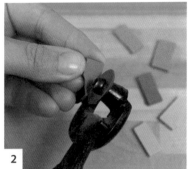

1 **2**

3

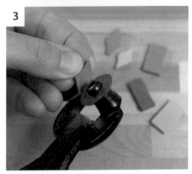

1 Starting with a rectangular half tile, nip one corner off cleanly by making a triangular cut from the centre of one long edge to the centre of one short edge.

2 Rotate the tile 45 degrees and make a similar cut on the opposite edge to meet in a point on the short edge.

3 Repeat steps 1 and 2 on the remaining two sides to form a diamond shape.

CUTTING RANDOM PIECES

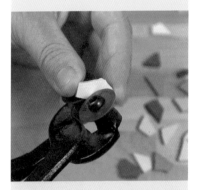

If you want to create an irregular mix of asymmetric tile shapes, simply place the tiles randomly between the wheels so that the edge of the tile is not parallel to the cutting jaws.

WHEELED NIPPERS MAINTENANCE
Tightening Wheels

Sometimes the wheels on the nippers will work loose, but avoid over-tightening the wheel screws as this will damage your nippers. The wheels should not move or rotate as you cut; if they do, they need tightening. Simply insert the Allen wrench into the screw head, as shown, and turn slowly clockwise using a gentle pressure until you feel the screw stiffen.

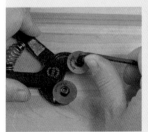 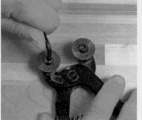

Sharpening Wheels

The cutting edges of the wheels will become blunt over time, and to maintain a sharp cutting edge,

the wheels can be rotated to provide a new cutting surface. Loosen the wheels by inserting the Allen wrench into the screw head and turning anti-clockwise until the wheel moves freely with your finger, as shown. Now turn the wheel a quarter turn and re-tighten the screw. Repeat with the other wheel.

Replacing Wheels

Remove the screw completely to allow the wheels to be lifted off and changed for a new pair. Remember that the flat side of the wheel should always be facing outwards, with the bevelled edge on the underside.

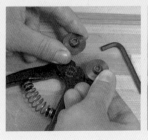 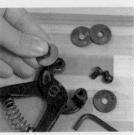

MOSAIC DESIGN BASICS

There are many different ways to lay tiles, from random, irregular patterns to disciplined lines and rows, and each of these tile-laying techniques has its own name. The *opus*, which is the Latin word for the creative work, refers to the laying down of the tiles in various formations, and *andamento*, the Latin word for the movement, 'flow' or 'coursing', defines the rhythm of the mosaic. It is possible to add extra energy to a mosaic by choosing an opus that activates and accentuates the motif. Tiling an outline or frame around an image will make it clearer and sharper.

Opus paladianum has tiles laid in an irregular, random pattern, sometimes called 'crazy paving'. Opus regulatum is created when tiles are laid in a regular grid, both horizontally and vertically. Opus tessellatum has tiles applied in straight rows, horizontally or vertically, resulting in a 'brick wall' effect. Opus vermiculatum outlines the shape of the mosaic motif, creating a 'halo' or aura effect. Opus musivum is created when opus vermiculatum is extended and repeated so that the entire area is filled. Opus classicum combines opus tessellatum with opus vermiculatum.

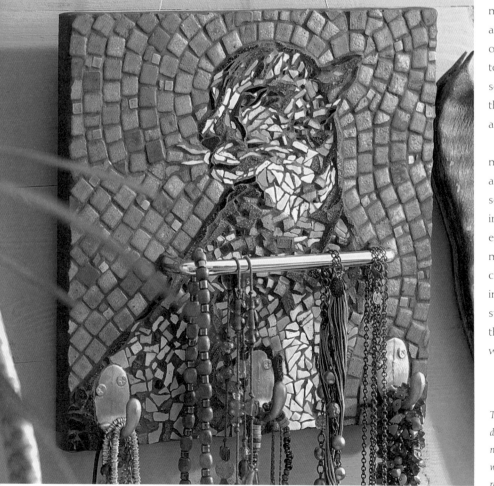

Where the gaps line up in a mosaic, your eye will draw a line, and so understanding the various opera (plural of opus) will help you to build a better mosaic. You will see examples of many of the opera throughout the projects in this book and one is shown here.

When we view a mosaic, our mind's eye takes all the small pieces and pulls them together to make sense of them and assimilate them into a whole piece. Your eyes will effectively fill in large areas of a mosaic to bring it together. When choosing a design for a mosaic, images with a strong line, pattern or structure are the most suitable; avoid those that may lose their integrity when fragmented and stylized.

The background of this leopard necklace board design (see page 77) is tiled forming an opus musivum pattern. Opus musivum is created when opus vermiculatum is extended and repeated to fill the entire background area.

METHODS OF LAYING TESSERAE

There are two different ways to make a mosaic, the direct method and the indirect method. All the projects in this book use the direct method. With the tiny pieces involved in mini, micro and nano mosaics, this is the only straightforward and practical method available to the maker. It allows the mosaic to be created and viewed the right way round and straight into its finished form. Most indoor mosaics, those that will not be given prolonged exposure to moisture, frost or extremes of heat or cold, are made using the direct method. Each piece of tile or bead is applied directly onto the base, either by 'buttering' the back of the tile or by applying a layer of glue to the surface of the base in which the tiles are pressed firmly. Once the design has been completed, the grout is applied directly to the surface of the mosaic.

The indirect or reverse method involves completing the design in reverse by gluing tiles upside down onto paper, using a solution of diluted PVA (white) glue (one part PVA to one part water). Once completed, the mosaic is then flipped over and set into an adhesive bed.

The Isis jewellery box design (see page 44) shows how opus tessellatum has been used on the sides of the box, laid to mimic a brick wall.

When the adhesive has set firm, the paper is soaked off and removed to reveal the mosaic the right way round and ready for grouting in the usual way. The indirect method is used extensively for outdoor mosaics and also for large installation mosaic artworks.

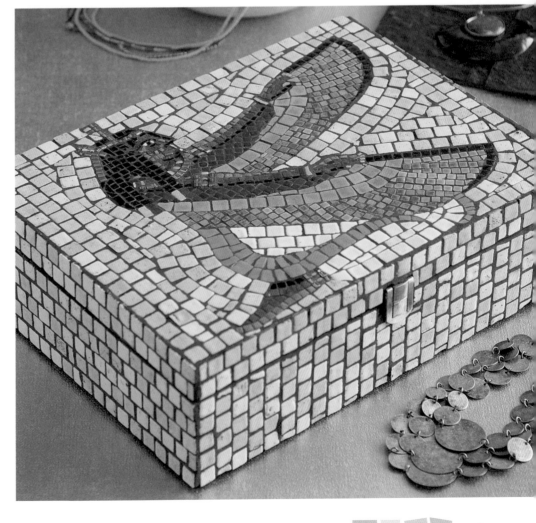

GROUTING

Grout is critical to a mosaic, as it acts as a secondary adhesive, bonding the tiles together to form a single smooth, unbroken surface. It stabilizes the mosaic, giving it added structural integrity and makes safe any uneven or sharp pieces.

CHOOSING GROUT COLOURS

The choice of grout colour will affect the overall look of the mosaic; it should unify and solidify your mosaic while enhancing the materials used and harmonize with the tile colours, giving an even weight and balance to each element in the design. If you are unsure of which grout colour to select for your mosaic, test a few options beforehand, as trying to change the colour of grout once it has been applied is problematic and often ineffective. Make up a sample of 10–20 tiles that you are using and try out a few colour combinations. As a general rule, white grout should be avoided, as it highlights the gaps and tends to emphasize any mistakes in the tile laying. Black will intensify the colours and grey will blend all the colours together and make the gaps disappear into the background. If you can only choose one grout colour, medium grey is the safest option.

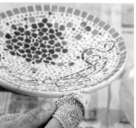

Palette knives enable small amounts of grout to be applied easily to micro mosaics, while a soft, damp cloth is ideal for smoothing grout edges.

USING POWDERED GROUT

All the projects in this book use powdered grout - as it can be mixed in small amounts and sets very quickly. It is strong and waterproof, making it ideal for use in humid conditions such as bathrooms. It is available from hardware stores and through mosaic suppliers (see page 126).

Powdered grout needs to be mixed with water to form a workable paste. It is available in many different colours, as well as standard black, white and grey, and with the addition of paint and pigment (see pages 23–24) can be mixed to a limitless palette of colours to match any item.

Powdered grout will store unopened for up to 12 months. However, once mixed it will begin to set and dry straight away, and within 30 minutes will usually become difficult to work. Once prepared, powdered grout can be fully hard in as little as an hour.

Grout drying time is affected by air temperature and humidity. Ideally, you should only grout when the temperature is between 5–30°C (41–86°F). You cannot grout a wet mosaic; your mosaic adhesive must be completely dry and the gaps between the tiles clean and free from small particles and dust. You should never wait more than 15–20 minutes before you start to remove excess grout.

Grouting can make a great deal of difference to the look of a mosaic. Although white grout is usually avoided as it tends to highlight the tile gaps, it was used very effectively on this cotton wool pot (see page 87) to give a clean, fresh and bright finish.

You will need

Dust mask

Rubber gloves and apron

Newspaper

Packet or tub of powdered grout

Water

Weighing scales and measuring jug

Glass jar, tray or plastic container

Palette knife

1 Grouting should always be carried out in a well-ventilated area, and a dust mask is recommended to avoid inhaling the powder. As grout is cement- and sand-based, and thus can be caustic, it is essential to wear protective rubber gloves and an apron. Spread some newspaper onto your work surface to protect it. The grout packet or tub will specify the ratio of powder to water, so read the instructions carefully before opening. As a general rule, 100g (3½oz) powdered grout will need 20–25ml (0.6–1fl oz) water. Weigh out the required amount of powdered grout (1a). Measure the recommended amount of water into a measuring jug (1b).

2 Put the powdered grout into a glass jar, tray or plastic container (2a). Begin to add the water to the powder. Stir continuously and slowly with the palette knife, adding the water a little at a time until a smooth paste has formed and all the powder has been absorbed (2b).

PREPARING POWDERED GROUT

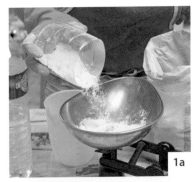 1a
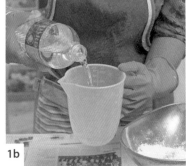 1b

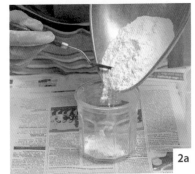 2a
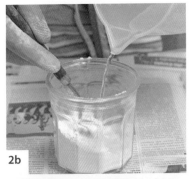 2b

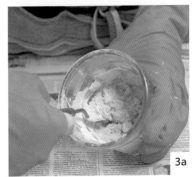 3a
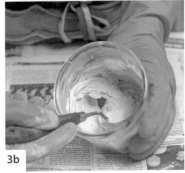 3b

3 Let the mix stand for 2–3 minutes and stir again before use (3a). Do not beat or whisk the mix, as this will trap too much air. Ideally, you must use the grout within 20 minutes for optimum application.

If you have added too much liquid, you can compensate by adding a little more powder, and if the mix is too dry, more water can be added until a smooth paste is produced (3b). But don't use the grout if the mix is too watery, since cracks may appear as the grout dries and cause air pockets to form in the spaces between the tiles (the joints or interstices).

COLOURING POWDERED GROUT WITH PAINT

You will need

Dust mask

Rubber gloves and apron

Newspaper

Packet or tub of white powdered grout

Water

Weighing scales and measuring jug

Glass jar, tray or plastic container

Acrylic paint

Palette knife

Tip WHEN COLOURING GROUT ALWAYS MIX MORE THAN YOU NEED, AS IT WILL BE IMPOSSIBLE TO MIX EXACTLY THE SAME COLOUR AGAIN IF YOU FIND THAT YOU HAVE NOT MIXED ENOUGH.

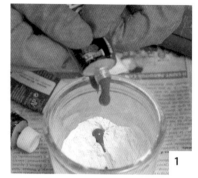

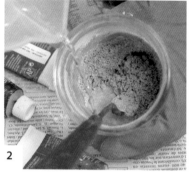

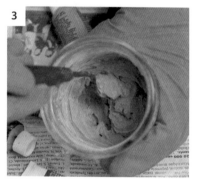

1 Prepare the work surface and ingredients as step 1 on page 23. Put the powdered grout into a glass jar, tray or plastic container. Select your chosen paint colour (or colours if you are combining more than one) and squeeze the desired amount onto the powder. Carefully and slowly add some water. The amount that you would normally add should be reduced to take into account the addition of the paint.

2 Stir continuously and slowly with the palette knife, adding more paint or water as required until a smooth paste has formed and all powder has been absorbed.

3 Let the mix stand for 2–3 minutes and stir again briefly before use.

The white powdered grout will lighten the tone of the paint, so it is effectively like mixing a white paint with it, and the final colour of the grout will lighten when drying. You therefore need to consider carefully the depth of colour you would like to achieve at the beginning in order to add the correct amount of paint before you add the water.

COLOURING POWDERED GROUT WITH PIGMENT

Pigment is finely ground powder made from pure minerals, metal oxides or salts. The pigment powder is added to the powdered grout before the water is added. Whereas the water content is reduced by the addition of paint to powdered grout, the water content is increased with the addition of pigment, as the pigment increases the powder content. As a general rule, 10 per cent is the maximum ratio of pigment recommended to maintain the full strength of the grout structure.

Liquid pigment colorants can also be used to colour grout. They should be treated in the same way as acrylic paint (see above) and the water content of the mix reduced accordingly.

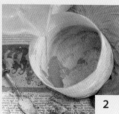

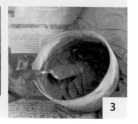

HOW TO GROUT A MOSAIC

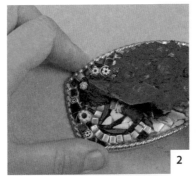

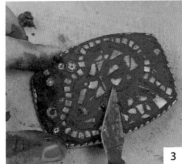

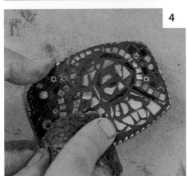

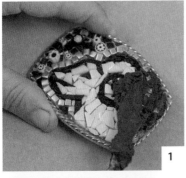

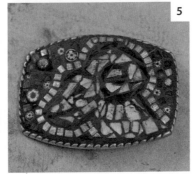

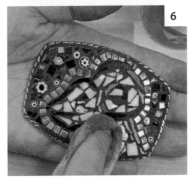

1 Load the palette knife with grout and apply pressure to squeeze the grout down into the gaps between the tiles by drawing the flat edge of the knife across the tile surface gently and evenly.

2 To embed beads and other protruding objects, use the pointed or rounded tip of the knife to press the grout in around the object. Spread the grout over the entire surface until all gaps are filled.

3 Clean off the palette knife and carefully scrape away excess grout from the surface, wiping it back into the pot. Do not gouge or dig any grout out from the gaps; keep the knife level and the action smooth. Leave to set until just firm (after about 20 minutes). If it moves when pressed, it isn't ready.

4 With larger items, a just-moist sponge or soft cloth is perfect for removing the excess grout from the surface. With smaller objects, remove the grout with a gloved finger or tiny paintbrush. If you notice that the grout is washing out from the gaps, it isn't quite set enough so wait for it to dry a little harder. Work the surface methodically and check the grout consistency at all times. Wash your hands and/or the sponge/cloth regularly so that you are cleaning the surface and not continuing to spread the excess grout.

5 Your mosaic should now be left with a film or 'haze' on the surface of the tiles. This residue can be left on the surface until the grout is completely set.

6 Once the grout had dried completely, the layer of residue can be removed with a clean, dry soft cloth and a spray of household furniture polish.

It is common for dots of grout to remain in pinholes and surface creases of glass tiles after cleaning. To remove any remaining grout haze, wait a few days for the grout to fully cure before applying a wash of household white vinegar across the mosaic surface. This will give the tiles a mirror-like sheen and remove any residual grout from the surface.

If some grout still remains after this vinegar wash, a hydrochloric acid tile cleaner can be applied. As with all chemical substances, it is important to follow the manufacturers' instructions when using, and also to wear the appropriate protective clothing.

JEWELLERY-MAKING BASICS

Micro mosaic work is perfect for jewellery and this section describes
how to make simple earring loops and finish a necklace with thonging.
Once you are confident with the mosaic techniques covered in this book
you will feel able to experiment with other jewellery-making techniques.

MAKING EARRING LOOPS

You will need

Beads

2 head pins

Wire cutters

Round-nosed pliers

Pair of ear wires or hooks

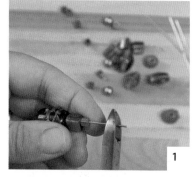
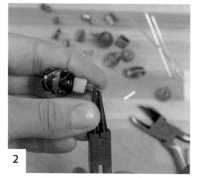

1

2

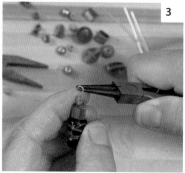
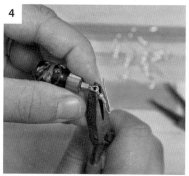

3

4

1 Thread a bead or beads onto
a head pin and cut the head
pin to the desired length with wire
cutters. It is essential to leave at
least 1cm (³⁄₈in) at the top of the pin
so it can be shaped.

2 Using the round-nosed pliers,
grip the top of the head
pin firmly just above the top bead
(leaving a small gap so that you can
move the pliers), or 1cm (³⁄₈in) from
the top of the head pin, and bend
the wire to a 90 degree angle.

3 Keeping a firm grip on both
the earring and the handles
of the pliers, rotate the pliers to
form a loop. Bend the wire as far
round as you can with a smooth,
even movement.

4 Keep rotating the wire until
a complete loop is formed,
leaving a small gap on which
to thread the ear wire or hook
before closing. Repeat for the other
earring. It may be necessary to
release your hold on the pliers and
reposition your grip during the
looping process, but be careful not
to remove the pliers from the loop
until the full circle is formed.

Tip YOU CAN MAKE A SMALLER
LOOP BY WORKING CLOSER TO THE TIP
OF THE ROUND-NOSED PLIERS OR A
LARGER LOOP BY WORKING FURTHER
BACK TOWARDS THE BASE OF THE PLIERS.

FINISHING A NECKLACE CORD OR THONGING

You will need

Cord or thonging

2 spring ends

Superglue

Flat-nosed pliers

2 jump rings

Lobster clasp

Extension chain

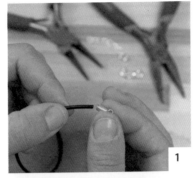

1 Insert the end of the piece of cord or thonging into a spring end, as shown in the first picture.

Tip APPLYING A SMALL DOT OF SUPERGLUE TO THE CORD OR THONGING BEFORE INSERTING IT INTO THE SPRING END WILL HELP KEEP IT SECURED.

2 Using flat-nosed pliers, squeeze (crimp) the last coil tightly against itself until it is flat and the cord or thonging is secure.

3 Repeat for the second side of the cord or thonging. The loops on the spring ends are now ready for attaching to the jump ring and lobster clasp.

1

2

3

4

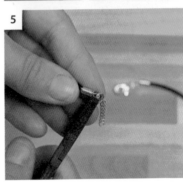

5

4 Twist open the jump ring and loop it through one of the spring end loops and the lobster clasp, as shown, then close tightly.

5 Now attach another jump ring to the other spring end and add an extension chain (see page 13). Close the jump ring securely to finish.

Tip EXTENSION CHAINS CAN BE USED IF YOU ARE NOT QUITE SURE OF THE LENGTH OF THE PIECE OF THONGING YOU WILL NEED. THE WEARER CAN THEN EITHER LOOSEN OR TIGHTEN THEIR NECKLACE FOR COMFORT.

Blossom Pendant and Earrings

Seed beads are remarkably versatile and can be used very effectively to produce fine detail on small items, such as earrings and necklaces, where even the smallest mosaic tiles would look too big. These beads are available in an enormous range of colours and finishes so the possibilities are endless. All you need is a steady hand and plenty of patience! The blossom pendant and earrings here and the magnolia variation shown on page 31 are the perfect projects to get you started.

You will need

Silver-plated round pendant base
5cm (2in) diameter, with metal loop fitting

Pair of silver-plated oval earring bases with ear hooks
6.5cm (2½in) long

Silicon adhesive

Seed beads
(11º) in mixed reds, greens, silver, white and black

Pale pink grout
(see page 23)

Mauve ribbon
120cm (47in) long

Making time: 1½–3 hours

Drying time: 20 minutes–1½ hours

Weight: pendant 25g (1oz)

earrings (pair) 30g (1oz)

THIS BLOSSOM PENDANT AND MATCHING EARRINGS ARE SIMPLE TO CREATE AND AN EXCELLENT STARTING PROJECT FROM WHICH TO EXPLORE THE MANY POSSIBILITIES THAT SEED BEADS OFFER.

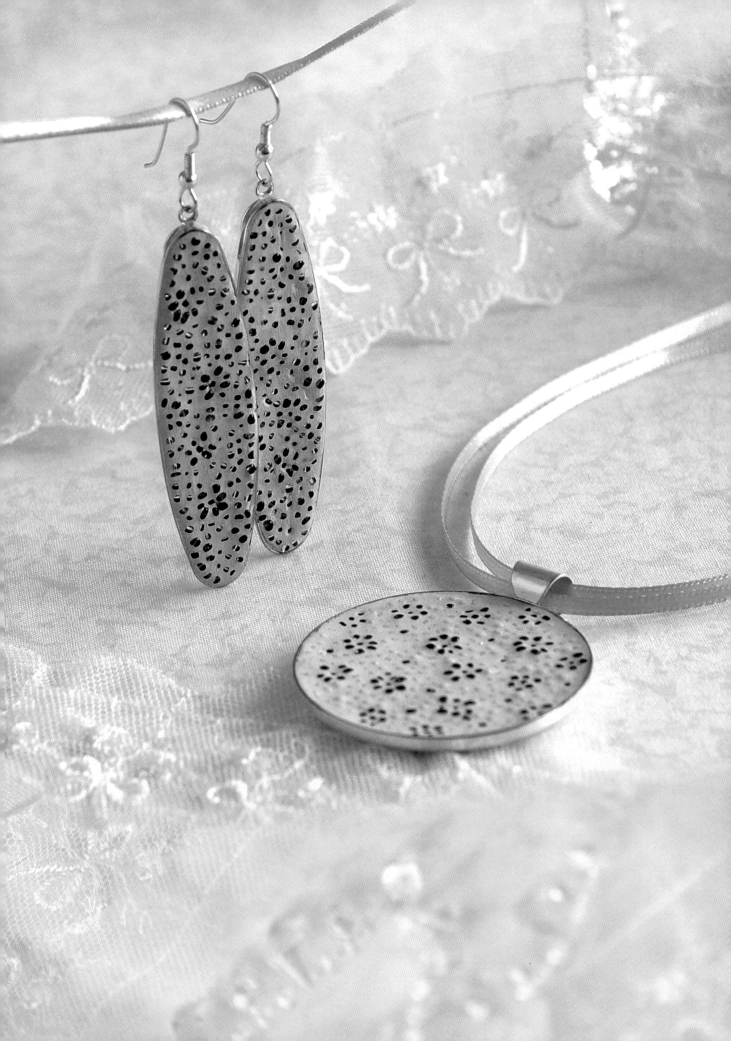

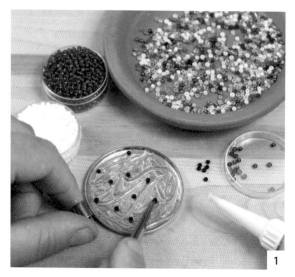

1

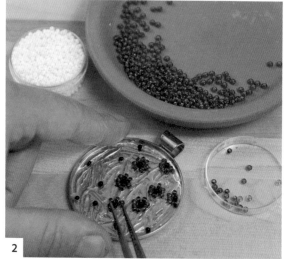

2

3

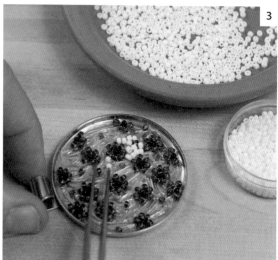

4

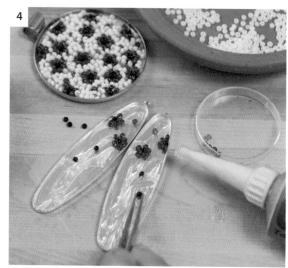

1 Separate the seed beads into colours (see Tip on page 34). Spread a fine layer of silicon adhesive over the pendant base and space 16 black seed beads randomly into the glue to form the blossom centres.

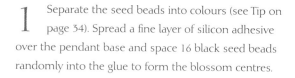

Tip IT IS INEVITABLE THAT SOME BEADS WILL FALL OVER WHILST TILING. USING TWEEZERS WILL HELP YOU CONTROL THEM AND MOUNT THEM CLOSER TOGETHER.

3 Dot a few green beads in between the blossoms before filling the remaining space around the flowers with white beads, fitting them snugly up to the raised rim of the base.

2 Now select red seed beads to form the petals and place six or seven of these around each centre. Make some half flowers by placing the central black bead at the rim and then place just three or four petal beads in a semicircle. Keep the threading hole hidden by tiling the bead on its side, so that once grouted the bead will become a solid dot, rather than a ring of colour.

4 The earrings that complement the pendant are made in the same way. The design for the earrings has been varied slightly, with some shiny silver beads used in between the white beads of the background and more half flowers are placed nearer the rim. Leave to dry completely.

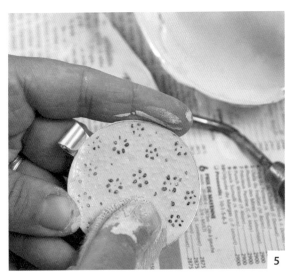
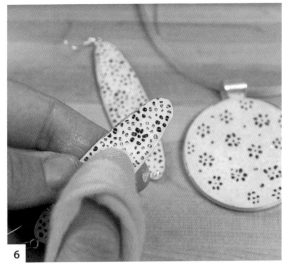

5 Mix a very small amount of pale pink grout (see page 23) and press it firmly down into the tiny gaps between the beads to embed them. Wipe away any excess grout straight away so that none of the 'dots' of colour are lost. Be careful not to remove too much grout; just enough to reveal the tops of all the beads.

6 Once the grout has hardened buff up the surface of the beads with a spray of furniture polish and a soft cloth. Attach some ear hooks or ear clips. For the pendant, thread two pieces of ribbon through the loop and tie together to form a soft knot. Alternatively, you could make a beaded necklace cord, as described below.

MAGNOLIA PENDANT AND EARRINGS

This pretty set has been made in the same way as the blossom set but has a more traditional feel. Templates are on page 112 if required. The bases used for the earrings are slightly larger so have been finished with clip-on findings but can be adapted back to pierced ear hooks.

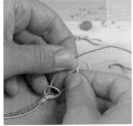
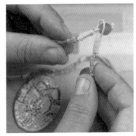
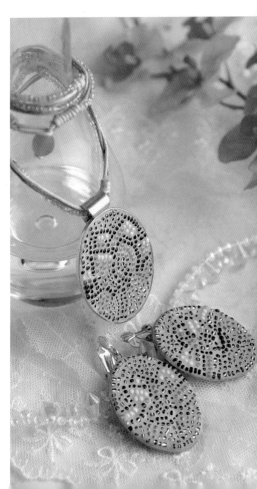

The seed bead and cotton cord chain is made by knotting together three separate strands to form a pendant fixing. Thread a length of invisible cord with a mixture of silver and pink seed beads. Cut a length of mauve cotton cord to the same length as the beaded strand and a length of pink cotton cord a third longer. Starting at one end of the cord use the pink cotton cord to wrap and knot the three strands together and continue to wrap and knot at 5cm (2in) intervals. A dot of glue on the knots and ends will stop the cord slipping. A large pink bead has been used at one end over which the loop can fasten. Once finished, thread the completed cord through the pendant hanging.

Daisy Bracelet and Ring

Like pointillist paintings, which are made up entirely of dots of colour, seed bead jewellery is slightly abstract when viewed close up and gains clarity when seen from a short distance. When set tightly together seed beads are naturally alluring, tactile and intriguing to the eye. The simplicity of this daisy design and the use of darker surrounding beads and grout gives the flowers clarity and definition. The ring and bracelet bases have adjustable bands at the back to fit any wrist or finger.

You will need

Silver-plated round ring base
2.5cm (1in) diameter

Silver-plated blank oval ring base
4cm (1½in) long

Seed beads
(11º) in white, gold, cobalt and dark blue

Mid-blue grout
(see page 23)

Silicon adhesive

Making time: 1–2½ hours

Drying time: 20 minutes–1½ hours

Weight: bracelet 20g (¾oz)

ring 5g (⅛oz)

THIS ELEGANT DAISY RING HAS GOLD BEADS IN THE CENTRE AND A MIXTURE OF BLUES IN THE SURROUND. THE OVAL BRACELET HAS THE SAME SIZE DAISY SLIGHTLY OFFSET TOWARDS ONE ROUNDED EDGE.

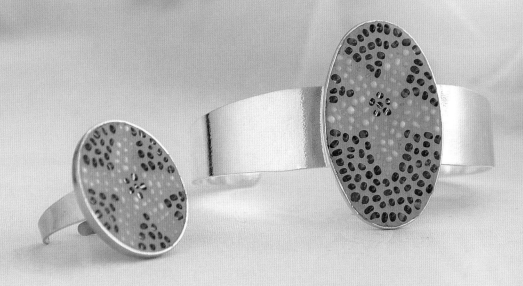

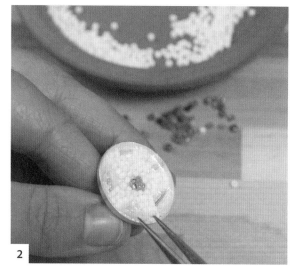
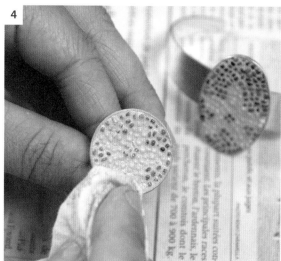

1 2

3 4

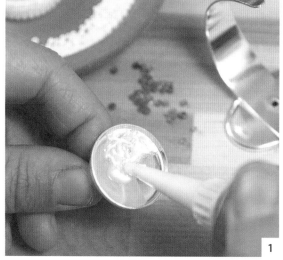
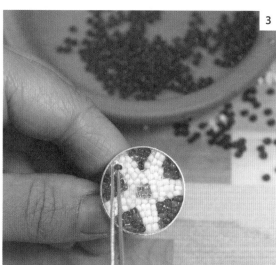

1 Sort the beads into piles of similar colours for the petals, centres and backgrounds (see Tip below). Spread a thin layer of silicon adhesive onto the ring base. Templates are given on page 112 if required.

2 Carefully glue six gold beads to form the centre of the daisy. Now tile the five petals out from these gold centre beads until they touch the rim of the ring base.

3 Fill in the background with a mixture of dark blue beads and leave to dry completely. Make the bracelet in the same way.

4 Mix up a small amount of mid blue grout (see page 23) and grout the pieces slowly and carefully, taking care not to dislodge any of the beads. Remove any excess grout gently from the surface of the beads whilst the grout is still slightly damp, as this will make it much easier to ensure that the tops of all the beads are exposed.

Tip WHEN SORTING SEED BEADS YOU MAY FIND IT EASIER TO POUR THEM ONTO A LIPPED SAUCER OR DISH TO STOP THEM ROLLING FROM THE TABLE OR BEING ACCIDENTALLY SWEPT FROM THE SURFACE.

Petites Fleurs

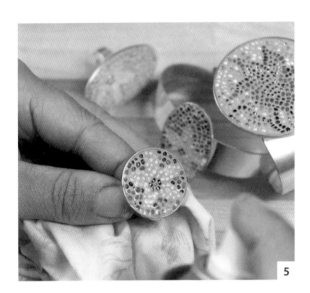

5 Use a small amount of household polish on a soft, clean cloth to help remove any grout that may linger on the ring rim or bracelet band. This will also give the jewellery an added glint.

IRIS BRACELET AND OVAL DAISY RING

In keeping with the floral theme this bracelet has a single delicate iris set against a subtle light blue background. Gold seed beads have been used to give the iris an extra sparkle in the centre and contrast with the azure/cobalt blues of the petals. It has been finished in a light sky blue grout. The same light blue grout was used to finish an oval daisy ring, which has been tiled with a turquoise blue and aquamarine green background to achieve a variegated effect. Templates for these designs are on page 112 if required.

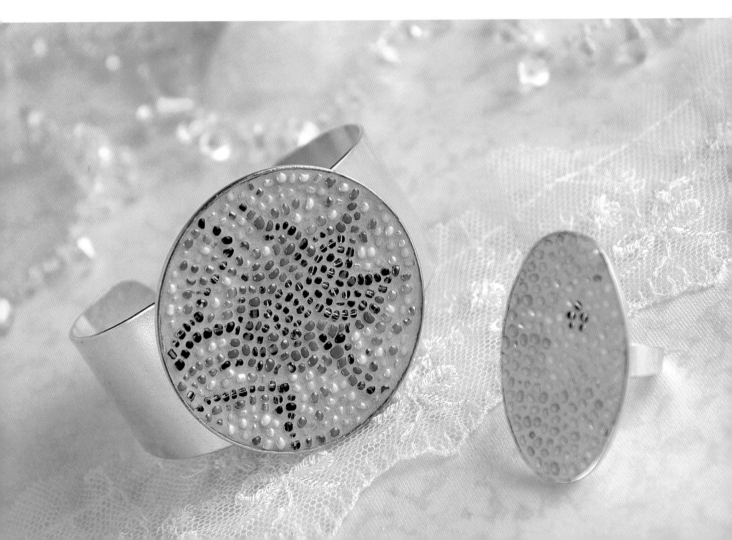

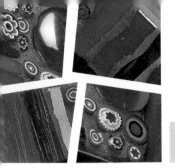

Chunky Cuff and Cocktail Ring

Plain wooden and acrylic bangles can be customized very effectively by adding mosaic to the surface with pieces of vitreous glass and beads in striking patterns. The results are stunningly eye catching but quick to achieve. The cuff combines bold glass gem beads in dazzling finishes with millefiori beads and iridescent, gold-threaded and marbleized glass tiles. A matching cocktail ring has huge impact and uses only a dozen millefiori beads or pieces of glass.

You will need

Wooden bangle base
9cm (3½in) square x 2cm (¾in) wide, with a 7cm (2¾in) diameter central hole

Silver-plated ring base
3cm (1¼in) square

Standard vitreous glass tiles
2cm (¾in) in a mixture of iridescent and gold-threaded reds and browns

Millefiori glass beads
4mm (⅛in) and 6mm (¼in) in a mixture of patterns, opaque and transparent

5 metallic and iridized red glass gem beads
2cm (¾in) diameter

Polyurethane adhesive

Dark brown grout
(see page 23)

Making time: 1½–3 hours (for both)

Drying time: 20 minutes–1½ hour

Weight: cuff 120g (4¼oz)

ring 15g (½oz)

WORN TO CAPTURE ATTENTION, THIS CHUNKY CUFF AND BOLD COCKTAIL RING ARE INTENDED FOR THE CONFIDENT PARTY-GOER WHO WANTS TO GET NOTICED! BOTH PIECES ARE LIGHTWEIGHT AND COMFORTABLE TO WEAR AND THE RING HAS AN ADJUSTABLE BAND TO FIT ANY SIZE FINGER SNUGLY.

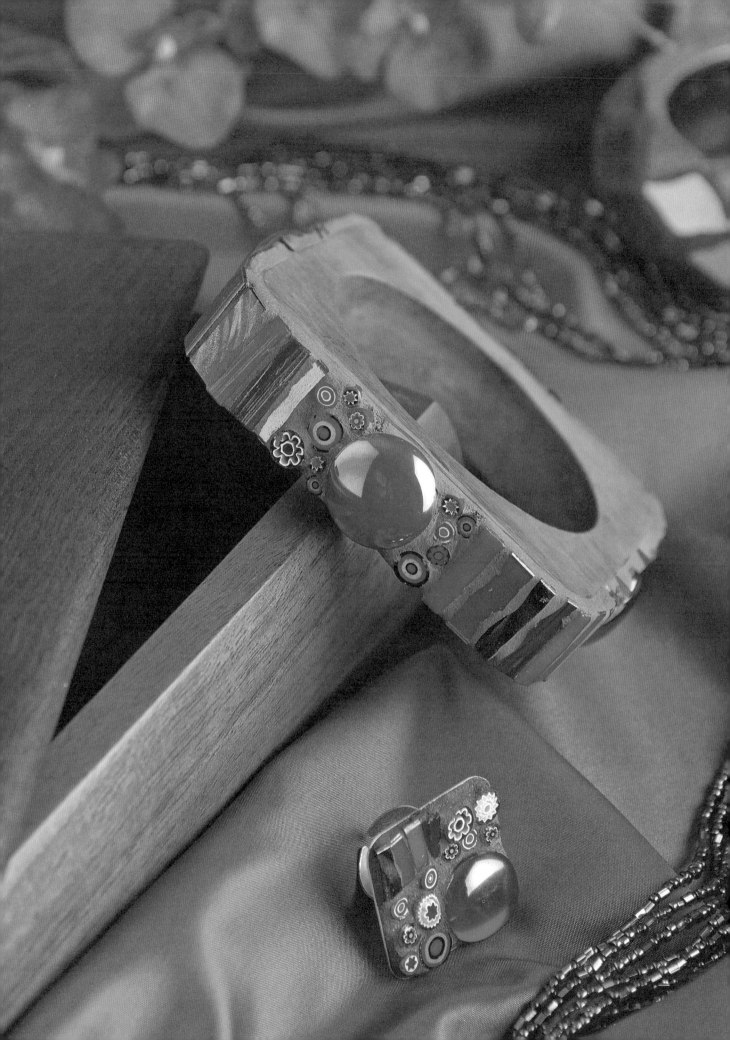

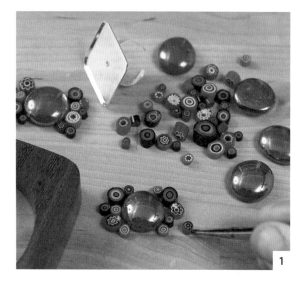

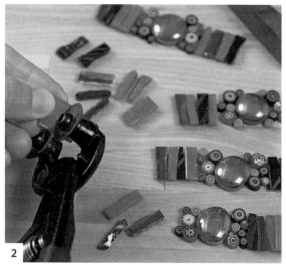

1

2

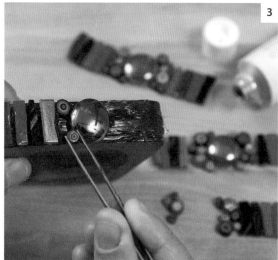

3

4

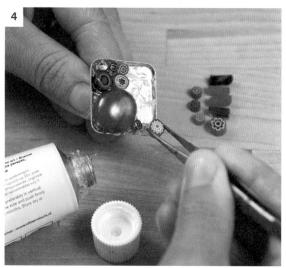

1 Decide on a colour scheme and design and sort
 and separate some glass gem beads and millefiori
beads ready to use. In this design a red and brown
scheme was chosen to complement the dark wood of
the bangle base. Patterns are given on page 113.

3 Spread a layer of polyurethane glue on one side
 of the bangle and begin transferring the pieces
systematically from left to right onto the bangle. Rotate
the bangle and tile the other three sides, taking care
not to dislodge any tiles from the finished sides as
you go around. Keep the tiles level with the top and
bottom edges of the bangle, as this will aid grouting and
improve the finish. Any protruding pieces should be
bought back in line before the glue dries.

2 Once the pattern of central beads has been
 chosen for the four sides cut the glass tiles into
strips by dividing them into thirds or quarters (see page
17) and place them either side of the central beads to
complete the rows. It is important to make the sides of
the bangle equal and balanced, although the pattern
of the strips and beads can vary on each side.

4 Tile a matching cocktail ring in the same way
 using a mixture of beads and cut tile pieces to
complement the bangle. Spread a layer of polyurethane
adhesive over the ring base and tile tidily and tightly,
keeping within the framing lip of the base. Wipe away
any excess glue that is on or near the surface of the
tiles immediately before it dries.

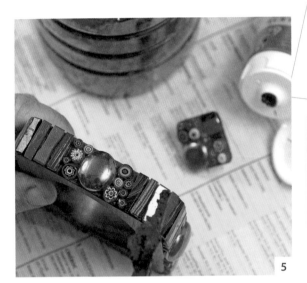

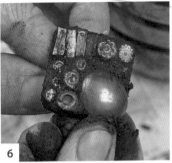

Tip IF IT IS DIFFICULT TO HOLD THE BANGLE SO THAT YOU DO NOT HAVE CONTACT WITH PREVIOUSLY TILED SECTIONS, AND THE PIECES ARE MOVING, IT IS POSSIBLE TO TILE ONE SIDE AT A TIME, LEAVING EACH SIDE TO DRY BEFORE TURNING TO THE NEXT EDGE.

5

6

5 Once the glue has set mix up a small amount of dark brown grout (see page 23) and begin to grout the bangle, pressing the grout firmly down into the tiny gaps to embed the beads and glass strips. A pointed palette knife is excellent for this. Seal the gap between the tiles and wood at the outer and inner edges and remove excess grout from the untiled wood quickly with a damp cloth to avoid permanent staining to the bases.

6 Once you have covered the bangle and ring in grout it is sometimes easier to remove the excess grout with your hands or a gloved finger. Use the tips of your fingers to gently rub around the beads with the grout teasing it into the tiny gaps and smoothing the surface as you go. Once completed a spray of furniture polish will bring up the shine and remove any lingering grout haze on the silver or wood.

BIG AND BOLD

These unique and contemporary items of jewellery have a glamorous and tactile quality perfect for special occasions. A harlequin cuff (far right) is tiled with vitreous glass pieces in a diamond formation (see pattern on page 113). Each piece has been cut from a single 2cm (¾in) tile ensuring that the only gaps are the ones that form the pattern and that there are no other cuts or gaps to draw the eye. The round blue cuff (top left) has four large marbleized blue pebbles set into a pattern of millefiori and glass gem beads. No cutting is required in this design, or for the matching oblong ring, which uses the same millefiori beads and metallic silver beads set into indigo-coloured grout.

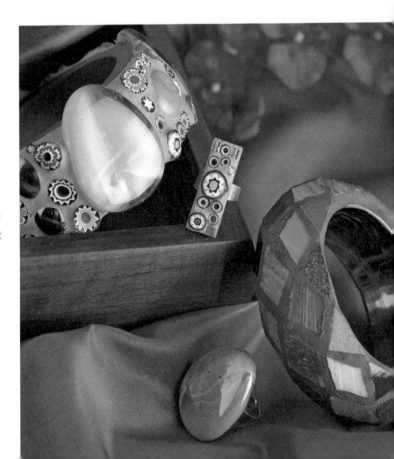

Mirror Stars Brooch and Earrings

These twinkling brooches would jazz up any festive outfit with their glittery silver mirror pieces. They could easily be adapted into large feature buttons for a stylish cardigan by gluing a snap fastener or press stud to them instead of a brooch pin. Children love sparkly jewellery and these small stars made into clip-on earrings are great for young girls to wear to parties. Children can make them very simply as the thin pieces of mirror tile are backed with fabric and can be cut safely with scissors.

You will need

Piece of 3mm (⅛in) plywood
10 x 10cm (4 x 4in), or two pre-cut 2.5cm (1in) wooden stars and one pre-cut 5cm (2in) wooden star

Fabric-backed mini mirror tiles
1.25cm (½in)

Red millefiori beads in star patterns
10mm (⅜in) and 6mm (¼in)

Red acrylic paint

Red grout
(see page 23)

PVA (white) adhesive

Brooch pin 3cm (1¼in) and clip-on ear stud backs 1cm (⅜in)

Superglue

Making time: ½–1½ hours

Drying time: 20 minutes–1½ hours

Weight: brooch 10g (¼oz)

earrings (pair) 10g (¼oz)

SPARKLY ITEMS OF JEWELLERY ALWAYS MAKE POPULAR AND EYE-CATCHING GIFTS AND THIS SILVER MIRROR BROOCH AND MATCHING EARRINGS WILL DELIGHT CHILDREN TOO.

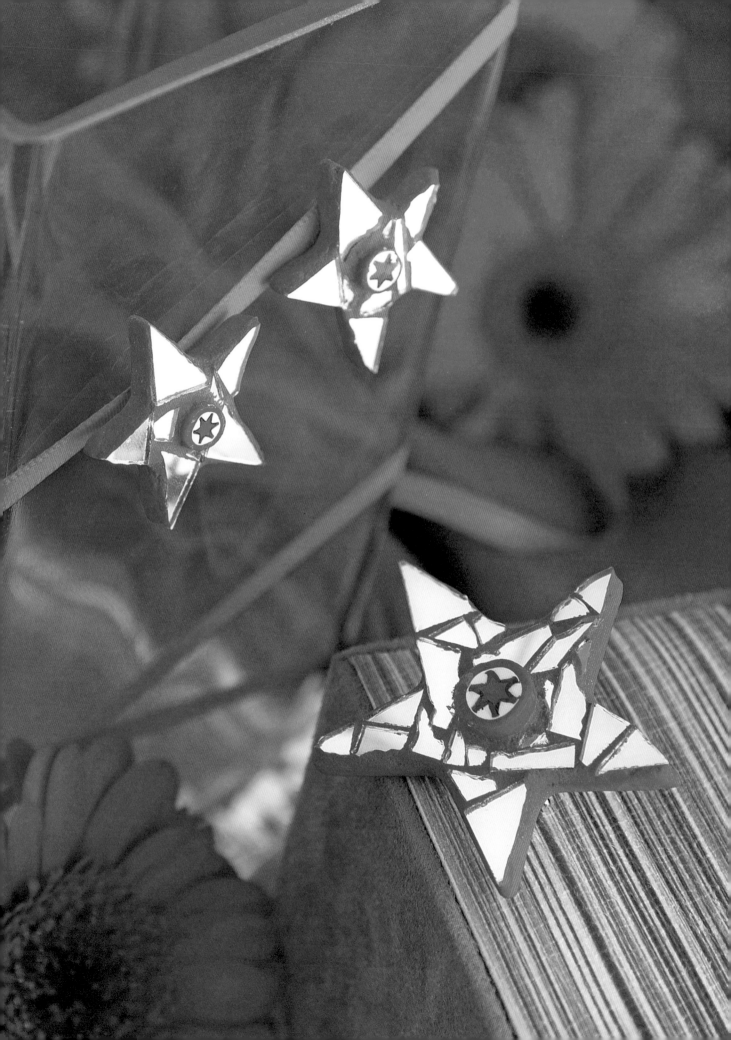

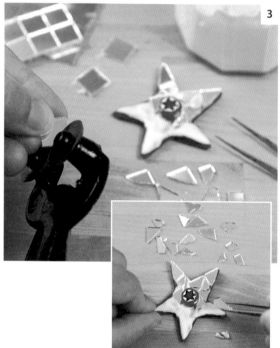

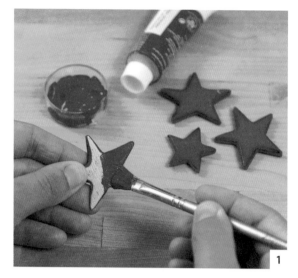

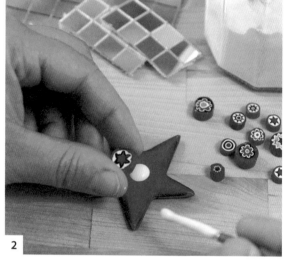

1 If you are not using pre-cut star shapes, use the templates on page 112 to sketch or trace and transfer the stars onto the wood (see page 110) and then cut out with a scroll saw. Sand them to a smooth finish to remove any splinters. Paint the stars all over with red acrylic paint and allow to dry.

2 Using the PVA (white) adhesive, glue a 1cm (⅜in) red millefiori bead to the centre of the large star and then a 6mm (¼in) millefiori bead to each of the smaller stars.

3 Peel the mirror tiles gently from their fabric backing sheet and cut into small pieces using tile nippers or sharp scissors. Tile the surface around the bead right to the edges (see Tip below left). Leave to dry completely.

CRESCENT MOON BROOCHES

These shimmering crescent moons are made in the same way as the Mirror Stars brooch, using pieces of flat and rippled coloured mirror glass. Great against a black jacket, they will glint when the light catches the surface. The template for this design is on page 113.

Tip WHEN USING THE MIRROR TILES, CHOOSE THE PIECES CAREFULLY, USING TRIANGULAR OR POINTED PIECES TO FILL RIGHT UP TO THE TIPS OF THE STARS.

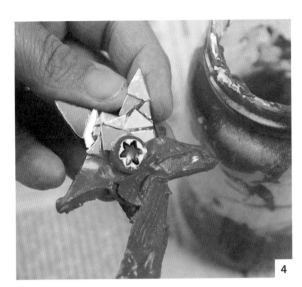

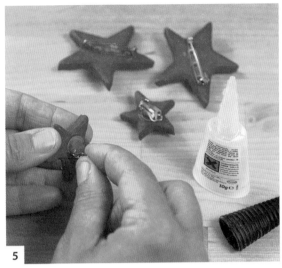

4 Grout the stars with red-coloured grout (see page 23), grouting the edges carefully to fill the gap between the mirror pieces and the wood. Use the tip of a pointed palette knife to scoop the grout around the beads to embed them. Once dry polish with a clean soft cloth.

5 Glue a brooch pin to the larger star and clip-on stud backs to the smaller stars. Pierced-ear stud backs could be used as an alternative fixing.

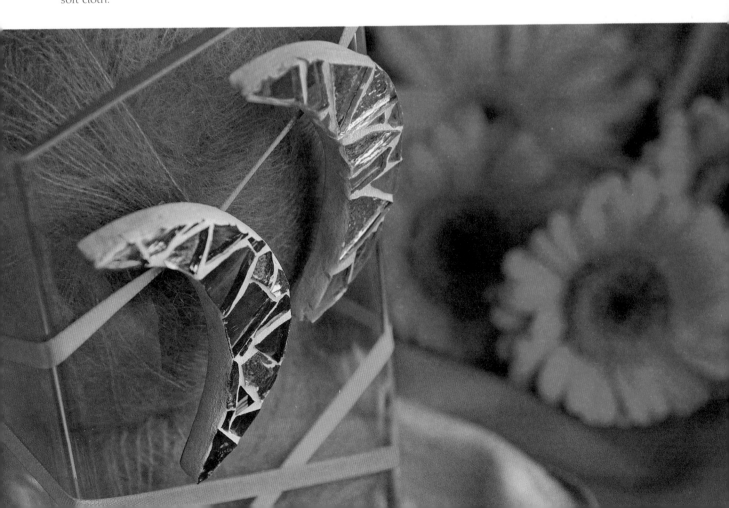

Isis Jewellery Box

Images taken from ancient Egyptian papyrus paintings make great mosaics and can be reproduced in exceptional detail with mini and micro mosaic tiles, as this jewellery box shows. Different opera, ways of aligning the mosaic tiles, have been used to emphasize the different areas of the image and small gold beads have been used alongside the tiles for extra richness. The box is divided inside into eight individual compartments each 6 x 9cm (2¼ x 3½in) and these can be divided further to create more sections or removed to open up the storage space.

You will need

Plain wooden jewellery box with hinged lid
28 x 20 x 8cm (11 x 8 x 3in)

White acrylic paint

Mini glazed ceramic mosaic tiles
in creams, tans, grey, white, orange and greens

Micro glazed ceramic mosaic tiles
in black, browns, greens, deep, bright reds, salmon pinks, tans and white

Gold metallic beads
3mm (⅛in) diameter

PVA (white) adhesive

Mid grey grout
(see page 23)

Cream felt or velvet
30 x 25cm (11¾ x 9¾in)

Four sticky-backed felt feet

Making time: 5–8 hours
Drying time: 20 minutes–3 hours
Size: 28 x 20cm (11 x 8in)

THIS ELEGANT BOX DESIGN FEATURES ISIS, THE WINGED EGYPTIAN GODDESS OF MAGIC AND THE GIVER OF LIFE. THE ELEMENTS OF THE DESIGN ARE CLARIFIED BY THE CAREFUL ALIGNMENT OF THE MOSAIC TILES.

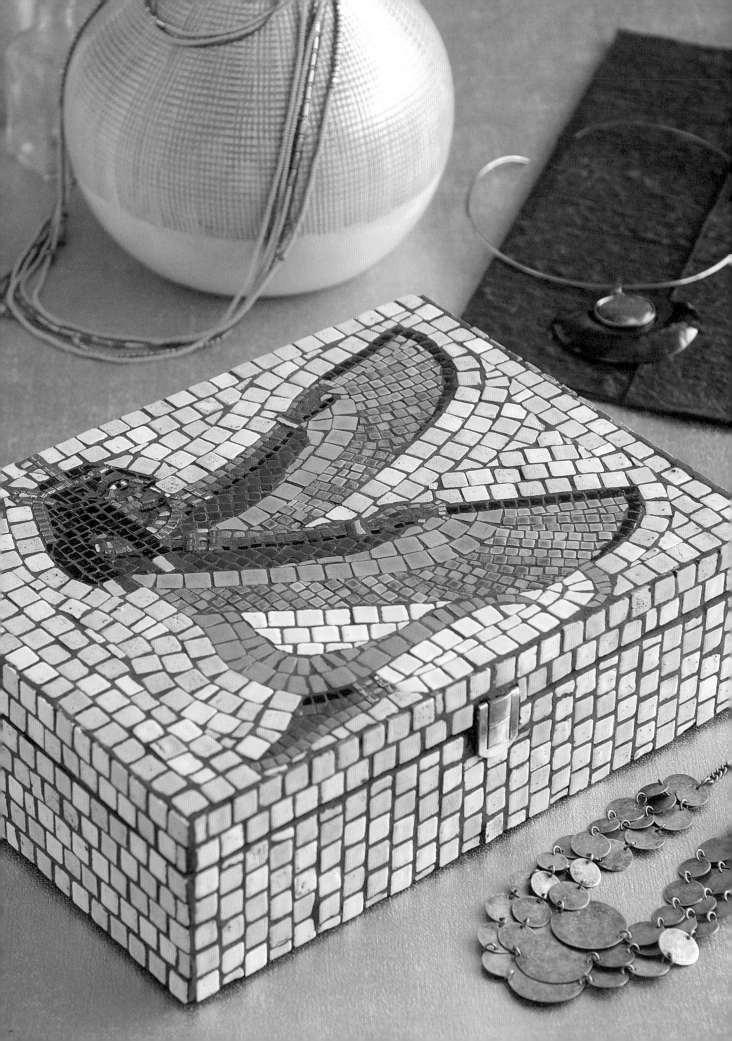

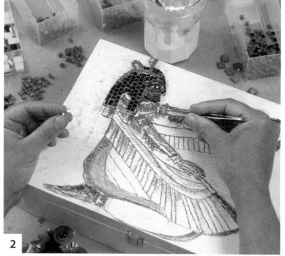

1

2

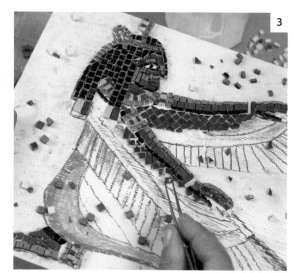

3

1 Apply one or two coats of white acrylic paint to cover the box and seal the surface. Paint very carefully around the hinges at the back of the box to allow the unobstructed opening of the lid (this side will not be tiled). Leave the paint to dry completely before transferring the design to the lid. See page 110 for how to trace and transfer this image onto the box using the template on page 114.

2 Once the design has been traced onto the lid fill in the different areas and colours to be tiled roughly using colouring pencils or wax crayons. Begin tiling the face and hair using micro black and brown tiles cut into smaller shapes where necessary to fill the spaces. Cut very small, thin black lines to outline the eye and define the nose and chin. Use two very small pieces of orange tile to form the lips and another two small pieces of white tile to frame the black of the eye. Gold beads, tiled on their sides to obscure the thread hole, form the headdress, necklace and bracelet bands on the upper arms and ankle.

Tip PAINTING THE SURFACE OF THE BOX WHITE WILL MAKE IT EASIER TO WORK ON AND ENABLE THE DESIGN AND COLOURS TO BE SEEN MORE CLEARLY.

3 Once the head and neck are completed tile the arms and feet in neat rows. Use darker browns for the underside of the arm and the shadow of the foot and lighter browns to show shading and tone on the upper part of the arms. Micro tiles in two tones of green were cut in half and tiled alternately to make the centre of the ankle band and arm bands, and a micro tile cut into quarters to make the fingernails. Tile the inside section of the wings in a chequered pattern of alternate deep red and bright red micro tiles, in a diagonal formation, as shown. Cut these in half diagonally to form two triangular shapes to finish the edges neatly where the wing meets the arm.

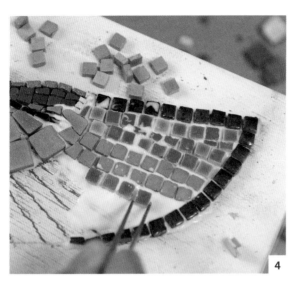

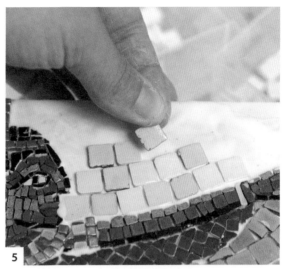

4

5

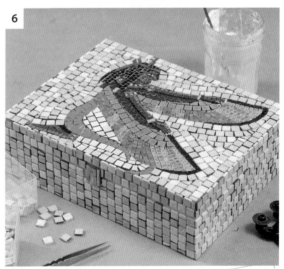

6

4 The feathers of the wings are edged with a row of dark brown tiles laid using opus vermiculatum (see Tip below) the feathers are then filled in using opus tessellatum (see step 6). Vary the tile colour every few rows from light salmon pinks to tan and ochre colours. Fill in the remaining sections of the body with the white and grey mini tiles.

5 The background can now be tiled with a mixture of mini tiles in varying shades of cream. Tile rows of whole tiles, cutting only a few of them where necessary to finish rows and fill awkward gaps.

6 Tile the sides of the box, again using opus tessellatum, applying the tiles in straight rows, either horizontally or vertically, like a brick-wall effect, so that none of the tesserae line up across the rows. Leave a slightly larger gap where the lid separates from the base so that you can distinguish the opening easily when grouting. Prop open the box whilst drying to avoid accidentally gluing the lid closed.

Tip TILES LAID USING OPUS VERMICULATUM CREATE AN OUTLINE AROUND A SHAPE GIVING IT CLEAR DEFINITION. 'VERMIS' IS THE LATIN WORD FOR WORM AND ILLUSTRATES THE WAY THE TILES 'SNAKE' AROUND A DESIGN, GIVING IT CLARITY AND ENERGY. OPUS TESSELLATUM IS THE NAME GIVEN TO TILES LAID IN A 'BRICK-WALL' STYLE. ROWS OF SIMILAR SIZED TILES ARE APPLIED IN STRAIGHT ROWS, HORIZONTALLY OR VERTICALLY. THEY SHOULD NOT LINE UP ACROSS THE ROWS, AS THIS WILL DRAW THE EYE.

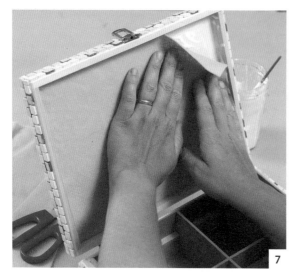

7

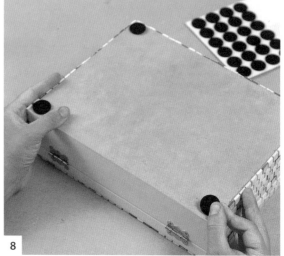

8

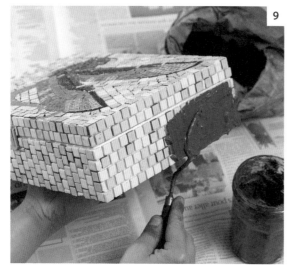

9

7 Measure and cut the piece of felt or velvet to fit inside the box lid and glue in place. This will help cushion any jewellery from damage should the lid accidentally shut down onto a protruding item.

8 Add four sticky-backed felt feet to bottom of the box in each corner, so that it will not scratch any household surfaces.

9 Spread the table with newspaper and grout the box using a mid-grey grout (see pages 23). Spread the grout all over the sides and the lid, making a note of where the lid separates so that you can remove the grout from this gap quickly before it sets. Remember to grout the gaps between the tiles and the wood on the opening seams, as well as at the bottom and the back of the box.

Tip USE A COUPLE OF PENCILS OR STICKS TO PROP OPEN THE BOX WHILST THE GROUT IS DRYING AND SO PREVENT IT STICKING TO THE BODY OF THE BOX.

SCARAB TRINKET BOX

This trinket or ring box with an ancient Egyptian scarab motif measures just 7 x 7cm (2¾ x 2¾in) and 4cm (1½in) deep. It is made in the same way as the Isis jewellery box but using smaller glazed ceramic micro and nano tiles. The template for this design is on page 115.

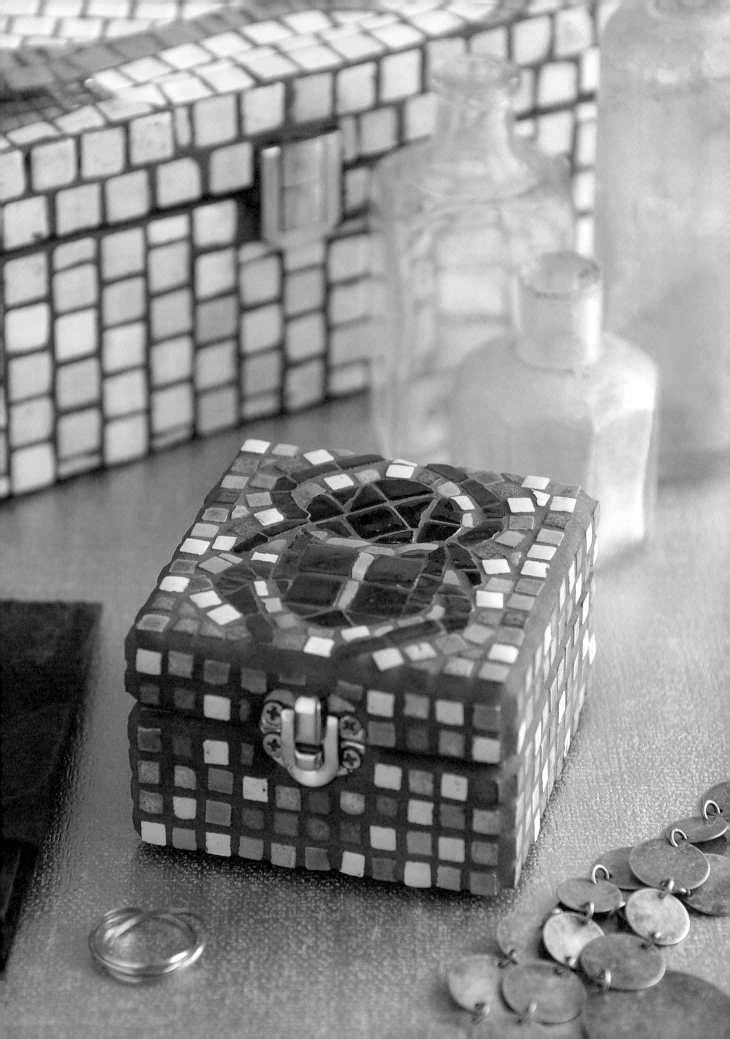

Egyptian Bangle and Necklace

This chunky bangle and necklace set can be tiled very quickly as no cutting is required. A plain plastic or resin bangle can be quickly transformed with some ceramic tiles and a few millefiori beads into a luxurious and classy bangle. It can be worn alone for simple elegance or stacked with other beaded bracelets for a dramatic layered look. The matching choker-style necklace is chic and understated and is made on a piece of memory wire that will always 'remember' its shape and return to its rounded form.

You will need

Round plastic/resin bangle
 7cm (2¾in) diameter x 4cm (1½in) deep

Acrylic pendant base 2.5cm (1in) square
 with two moulded hanging loops

Glazed micro ceramic tiles
 in gold, tan, green and cream

Mini glazed ceramic tiles
 in gold, tan and cream

12 green and white millefiori beads
 6mm (¼in) diameter

One green and white millefiori bead
 4mm (⅛in) diameter

Metallic gold beads 3mm (⅛in)

Black grout (see page 23)

Memory wire 2mm (1⁄16in) diameter
 14cm (5½in) long

Gold end cap bead 6mm (¼in)

Epoxy resin and polyurethane glue

Making time: 1–3 hours

Drying time: 20 minutes–1½ hours

Weight: bangle 115g (4oz)

 necklace 40g (1½oz)

THE BURNISHED GOLDS AND TANS ON THIS STUNNING BANGLE AND NECKLACE RECALL THE OPULENCE OF ANCIENT EGYPT AND MAKE A FINE SET.

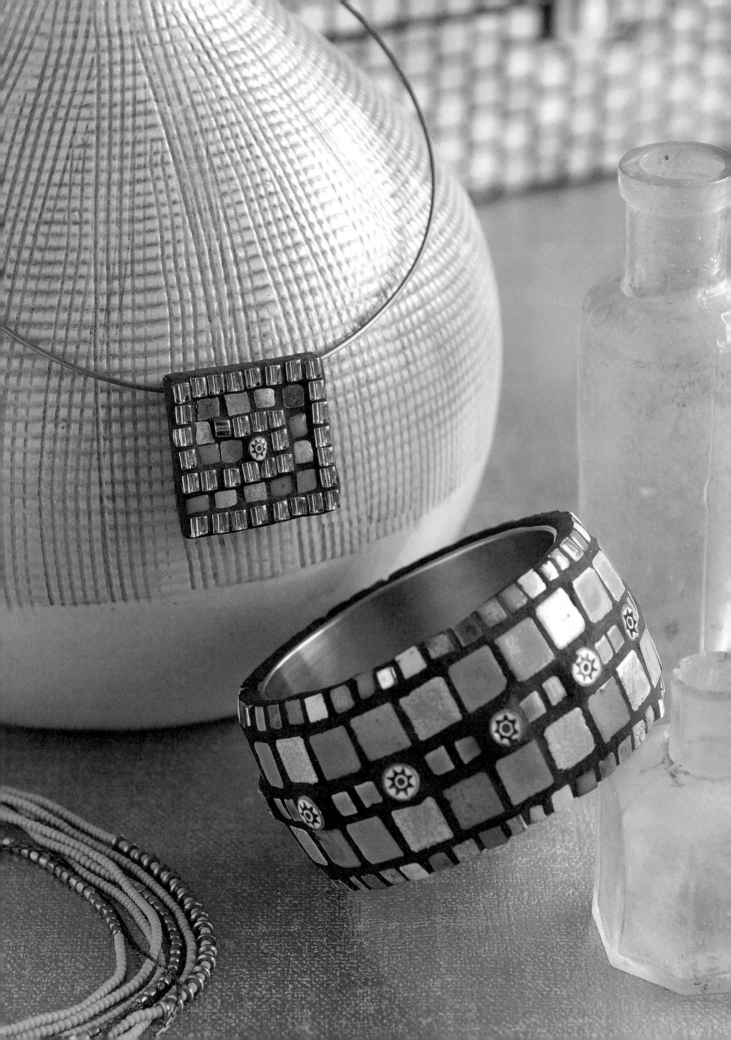

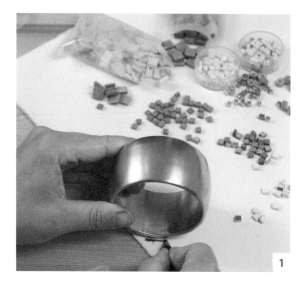

1

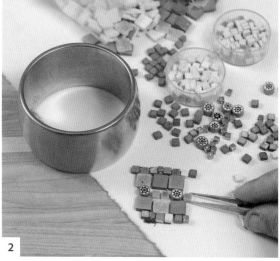

2

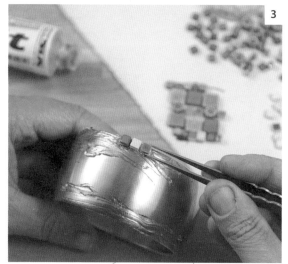

3

1 Spread out the tiles onto some white paper so that you can see the palette of colours easily. Mark the width of the bangle on a piece of paper, as shown, to help you work out the number of whole tile rows that can be fitted across the band. Patterns are given on page 115 if required.

2 Experiment with placing the tiles in rows in between the two pencil marks so that you can gauge how many rows it will be possible to fit into the space. You can build a small area to get a feel for the design and layout. In picture 2 you can see that it is possible to fit five rows of tiles into this bangle band.

3 Spread a layer of polyurethane glue all the way around the top and bottom edge of the bangle and tile a row of micro tiles in varying shades of tan and golden yellow in a continuous band. Add a few gold metallic beads every so often for a bit of sparkle. Make sure that the tiling is uniform and meets the edge of the bangle neatly. You may have to adjust the spacing slightly towards the end to fit the final whole tile.

Tip IT IS MUCH EASIER AND CLEANER TO TRY OUT DIFFERENT TILE PATTERNS BEFORE GLUING THEM TO THE BANGLE. AS THIS WAY YOU CAN AVOID GETTING IN A MESS WITH STICKY GLUE.

In Egyptian Mood...

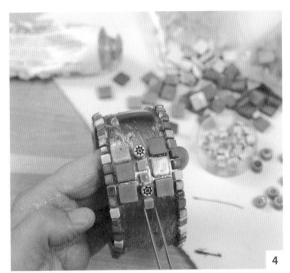

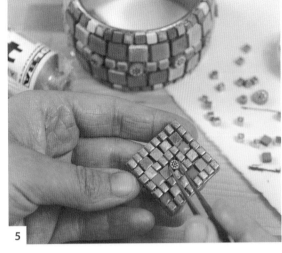

4

5

6

7

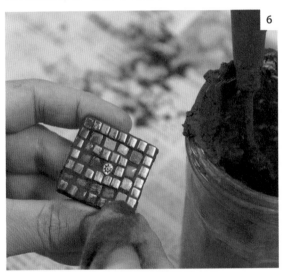

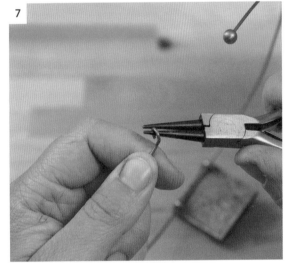

4 Spread more adhesive onto the centre of the bangle and begin tiling the two rows of mini tiles and a single central row of micro green tiles and 6mm (¼in) millefiori beads. Tile two micro tiles in between each bead. Again, adjust the spacing towards the end to make sure that the pattern is continuous and even with no half spaces or tight gaps.

6 Mix up some black grout to grout the pendant and bangle (see page 23). Remove any excess grout with a moist cloth and smooth the grout at the edges with a damp cloth for a tidy finish.

5 Leave the bangle to dry completely whilst you tile the pendant base in a pattern of beads and micro tiles as shown. A single matching 4mm (⅛in) millefiori bead finishes the centre of the pendant.

7 Cut the memory wire to the desired size with strong wire cutters and thread it through the loops on the back of the pendant base. Glue a gold end cap bead to one end of the wire with a dot of epoxy resin glue. Using round-nosed pliers turn a loop (see page 26) on the other end of the wire, leaving a slight opening at the bottom to allow it to overlap, and slot onto the bead end of the wire for a secure fixing.

Bijoux Bowl

This chapter features a bowl, brooch and chest, all inspired by the Art Nouveau movement that spread throughout Europe from around 1880–1920, and in particular the work of Alphonse Mucha (see page 61). The designs combine classic colours with flowing lines and delicate decoration. This bowl is useful in the bathroom as a repository for your gems whilst you bathe or on your dressing table filled with trinkets. It has a lightweight bamboo base and uses mini and micro glazed ceramic mosaic tiles. It could be used as a stylish soap dish or as a candle plate.

You will need

Bamboo bowl
20cm (7¾in) diameter

Glazed micro ceramic tiles 1cm (⅜in)
in mid grey, burgundy, deep red and pewter

Micro mosaic tiles
in black, copper, light blue and turquoise blue

Polyurethane glue

White grout
(see page 23)

Making time: 3–6 hours

Drying time: 1–2 hours

Size: 20cm (7¾in) diameter

THIS ELEGANT BOWL IS PERFECT TO HELP YOU KEEP ALL YOUR BITS AND PIECES TIDILY IN ONE PLACE AND IT LOOKS BEAUTIFUL WHEN IT'S EMPTY TOO. SEE PAGE 61 FOR DETAILS ON A MATCHING CHEST PROJECT.

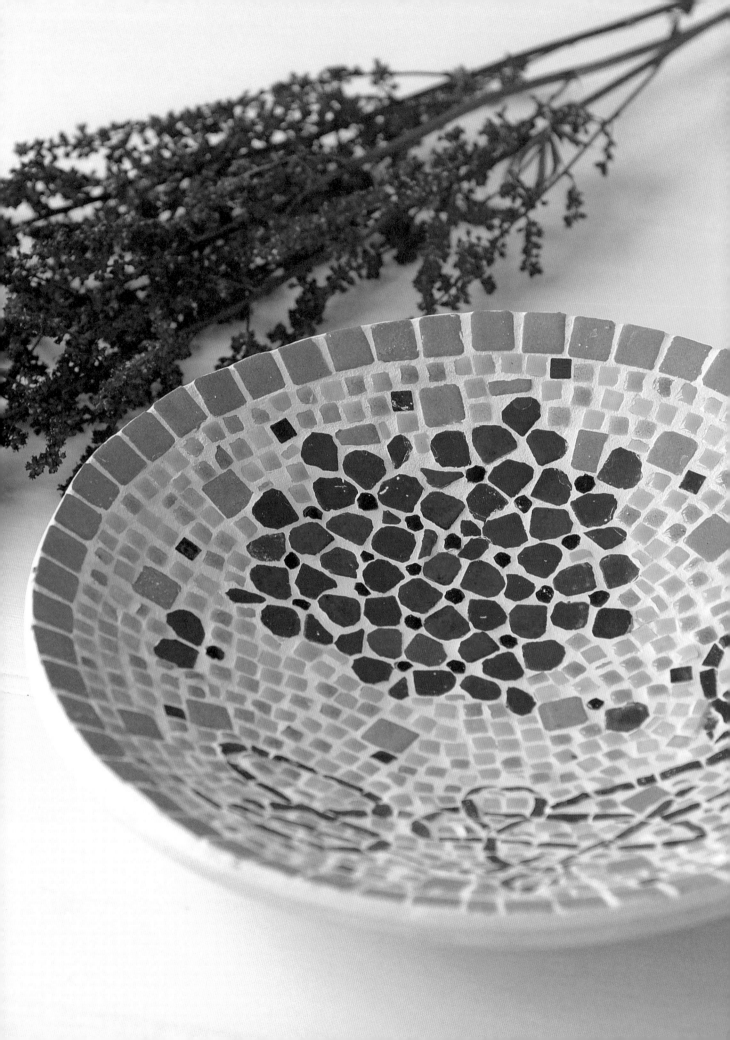

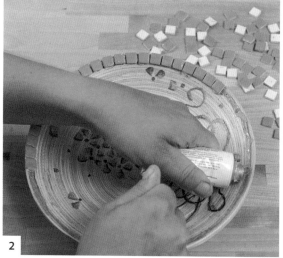

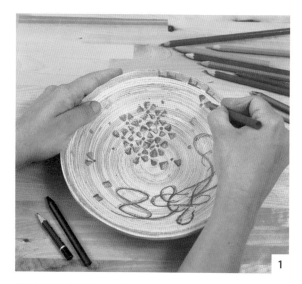

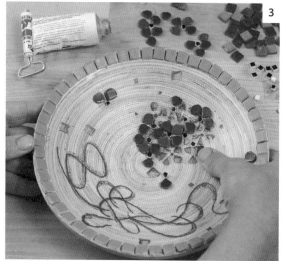

1 If the bowl is to be used in humid conditions, such as a bath/shower room you will first need to seal it all over by brushing with a solution of diluted PVA (white) adhesive (one part PVA to five parts water). Leave to dry. Using the template on page 116, sketch or trace and transfer the design onto the saucer and roughly sketch in the different coloured areas of the design with wax crayons and colouring pencils.

2 Using the polyurethane glue squeeze a neat layer of the adhesive around the edge of the bowl and begin tiling, using the mini glazed grey ceramic tiles (see Tip, left). Try to space each one evenly all the way around – you may have to re-adjust the spacing as you go, so that there are no cut tiles to draw the eye. Complete the line to frame the edge of the bowl.

3 Cut the mini burgundy and red ceramic tiles into petal shapes (see page 18) to form soft, stout petals, rather than long, thin ones (see Tip, right). Starting with a whole mini tile, leave two sides of the tile untouched and 'nibble' the other two edges into a rounded arc. Cut a few smaller and elongated petals to fill the gaps and form a cluster of flowers. To make the flower centres, nibble the corners from the black micro tiles to create rounded middles. When you have enough petals cut to size glue these in place. A few loose, breakaway petals can be glued slightly away from the main bunch for added effect.

Tip POLYURETHANE GLUE HAS NO VERTICAL SLIPPAGE SO IS GREAT FOR TILING ON ANGLED SURFACES. IT DRIES WATERPROOF AND FLEXIBLE. IT IS IMPOSSIBLE TO REMOVE ONCE SET AND CAN SIT UNTIDILY ON THE SURFACE OF THE GROUT, SO TAKE EXTRA CARE TO ENSURE THAT ANY EXCESS GLUE IS REMOVED BEFORE GROUTING, WHILST THE GLUE IS STILL SOFT.

 Art Nouveau Inspiration

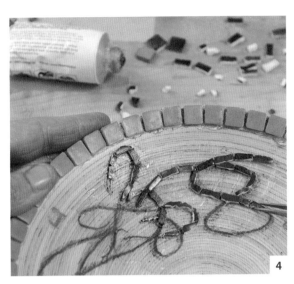

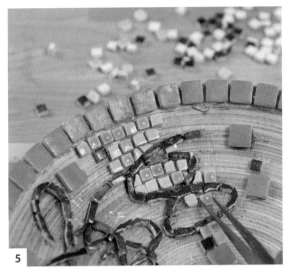

4

5

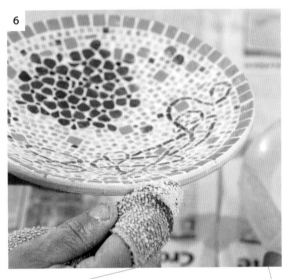

6

4 Now cut the mini pewter-coloured tiles into strips by dividing each one into thirds or quarters (see page 17) and tile the lines. To make more flowing curves the corner edges of the rectangles should always be parallel to each other. Trapezoid-shaped pieces will keep the arc of the curve tighter than regular rectangular-shaped strips (see Tip, below right).

5 Fill in the area around the flowers and swirls with the light/turquoise blue micro ceramic tiles. Dot a few mini grey tiles and micro pewter tiles through the background as you go. Leave to dry completely.

6 Grout the bowl with white grout (see page 23), making sure that the edge of the bowl is grouted to seal the gap between the tiles and the bamboo. Smooth the grout at the edge with a damp cloth for a neat finish.

Tip LAYING OUT THE LINES OF TILES FOR THE SWIRLS ONTO PAPER BEFORE GLUING THEM IN PLACE WILL HELP YOU EXPERIMENT WITH CURVING THE LINES AND WILL ALLOW YOU TO MOVE PIECES EASILY, BUILDING AND CHANGING THE PATTERN UNTIL YOU ARE SATISFIED WITH THE RESULTS.

Tip THE PATTERN OF PETALS AND SWIRLS IS VERY FREE FLOWING IN THIS DESIGN. TRY TO ALLOW THE SHAPES TO DEVELOP NATURALLY AS YOU TILE MAKING A DECISION AS TO HOW MANY OR HOW FEW PETALS OR LINES TO ADD AS YOU GO.

Bijoux Brooch

This elegant brooch design is a nano version of the bowl on page 55 and revives the classic 1900s style. It would look great on a smart coat or jacket. Alternatively, you could use it very effectively as a scarf clip or pin it to a plain beret for extra appeal. The lovely chest shown on page 61 is designed to complement the bowl and form a set. The chest is 18cm (7in) high, 25cm (10in) long and 19cm (7½in) wide, with two useful drawers that are each divided into six individual compartments.

You will need

Silver-plated round base
5cm (2in) diameter and 2mm (⅟₁₆in) deep

Nano glazed ceramic tiles
in black, grey, blue and turquoise

Resin tiles 1cm (⅜in)
in a mixture of red and pinks

White grout
(see page 23)

Silicon adhesive

Brooch pin with safety catch
3cm (1¼in) long

Superglue

Making time: 1-2 hours
Drying time: 20 minutes–1½ hours
Weight: 15g (½oz)

ELEGANT, ATTRACTIVE AND CHIC, THIS LOVELY BROOCH WILL ADD STYLE TO ANY OUTFIT. IT IS A PERFECT STARTER PROJECT IF YOU ARE NEW TO MICRO MOSAIC WORK.

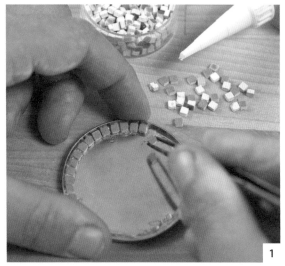

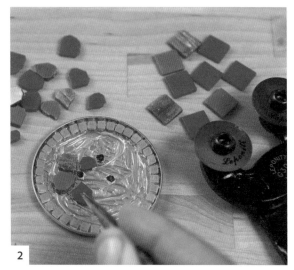

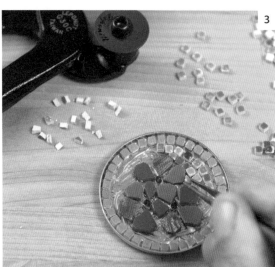

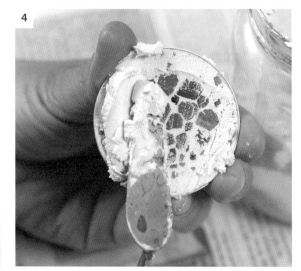

1 Start by tiling a row of grey nano ceramic tiles around the edge of the base, making sure that the gaps are evenly spaced and there are no cut tiles.

2 Cut the resin tiles into a range of petal shapes in the same way as before (see step 3 on page 56 and also page 18) and arrange in a random formation around three black nano tiles, which have been rounded slightly, as shown. A pattern is provided on page 116 if required.

Tip THIS BROOCH BASE HAS A RIM THAT FORMS A FRAME FOR THE MOSAIC AND KEEPS THE TILES NEATLY WITHIN THE CASING TO MINIMIZE DAMAGE.

3 Fill in between the flowers and the edge with a mixture of the blue/turquoise nano tiles, cutting them carefully where necessary to ensure that the spacing is even. Leave to dry.

4 Grout in the usual way (see page 23) with white grout, pressing the grout firmly into the tiny gaps to embed the tiles and making sure that the grout meets the rim of the base.

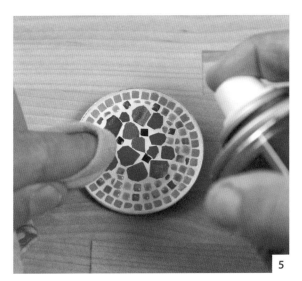

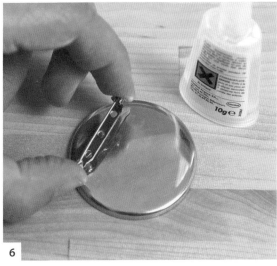

5 Allow the grout to dry completely before polishing the tiles with a clean, soft cloth.

6 Using superglue, fix the brooch pin to the back of the base as shown.

MUCHA TRINKET CHEST

In addition to the micro and mini ceramic tiles used on the bowl, some nano ceramic tiles have been incorporated into this Mucha-inspired chest design to allow for extra detail in the facial features and body. The body, hands and face have been picked out with unglazed ceramic tiles in muted cream and light terracotta shades. The mosaic detail on the drawer fronts has been tiled to make them interchangeable, continuing the theme down from the top through the flowers stretching from right to left and the branches curling around the knobs. The backgrounds have been tiled in a disciplined way, keeping all of the micro tiles square on to the structure, which makes the motifs appear to be slightly in relief and to the foreground. Each of the six compartments in the drawers measure 6 x 8cm (2¼ x 3in). The chest is finished in matt white with two antique silver knobs. The templates for this chest are on pages 117 and 118.

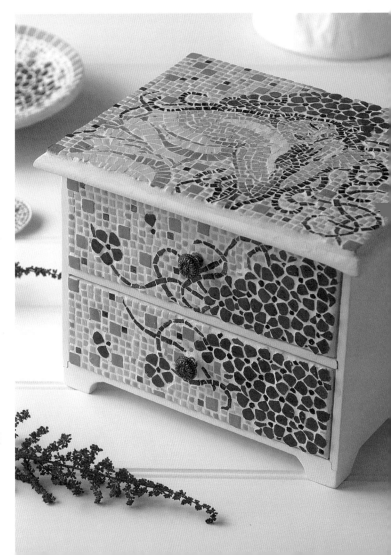

Leaves Photo Frame

This photo frame, with its mixture of textures and changing colours, has a vibrant and exciting look. It has fourteen individual mosaic leaves, finished in two green grout colours, appliquéd onto a background of autumnal oranges and browns. Once the leaves have been created you can experiment with changing the layout and formation by adhering them in any pattern you choose to fit any size of frame. You could try mounting them so that they break out from the edges of a single frame or tumble down the centre of a double frame.

You will need

Dark wood frame
55 x 28 x 2cm (21½ x 11 x ¾in) with four glass photo cut-outs each 14 x 9cm (5½ x 3½in)

14 MDF leaves
in a range of sizes and shapes or a 46cm (18in) square of 3mm (⅛in) MDF

Micro glazed ceramic tiles
in greens, browns and oranges

Vitreous glass and glazed ceramic mini tiles
in dark green, browns and oranges

Millefiori beads in all sizes
in oranges and browns, opaque and transparent

Standard vitreous glass and ceramic tiles 2cm (¾in)
in browns and oranges

PVA (white) adhesive

Polyurethane adhesive

Green and dark brown acrylic paint

Green grout and dark brown grout
(see page 24)

2 D-ring fittings for hanging the frame

Making time: leaves 7–10 hours; surround 4–6
Drying time: leaves 20 minutes–1½ hours;
surround 20 minutes–2 hours
Size: 55 x 28cm (21½ x 11in)

THIS IMPRESSIVE PHOTO FRAME CAPTURES ALL THE COLOURS OF AUTUMN. THE MOSAIC LEAVES ARE APPLIQUÉD ONTO THE FRAME TO GIVE A RAISED, THREE-DIMENSIONAL APPEARANCE TO THE SURFACE.

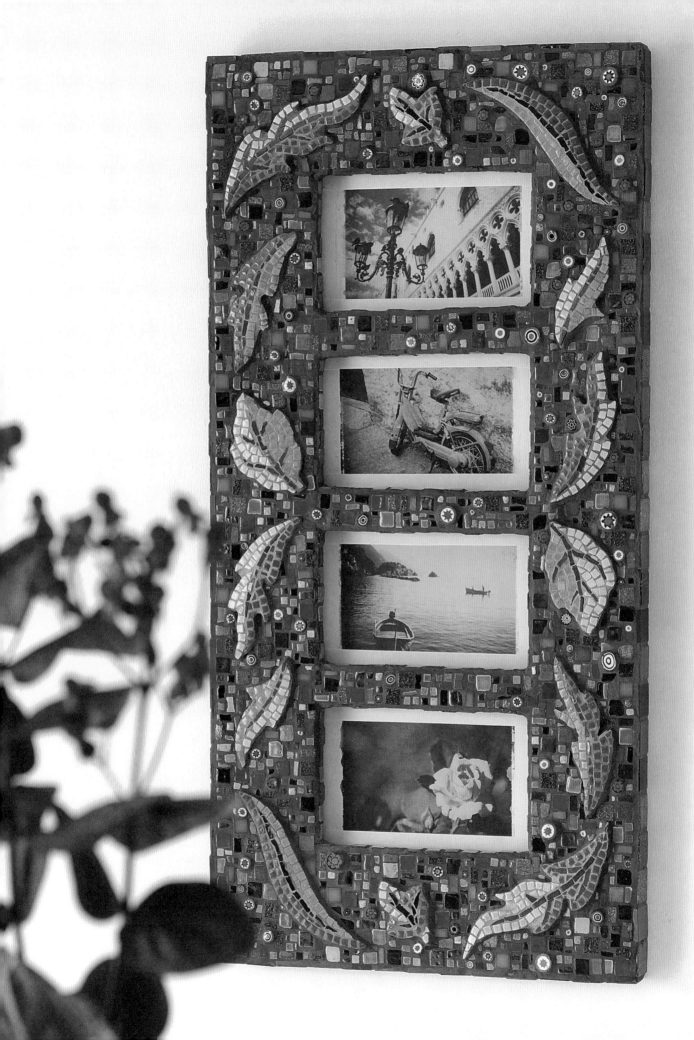

1

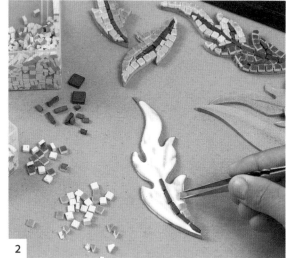

2

1 Remove the glass and mounting cardboard from the frame and set aside in a safe place. If you are not using pre-cut MDF leaf shapes, sketch or trace and transfer the leaves onto a piece of MDF and then cut out with a scroll saw (see page 110 for tracing a design instructions and page 119 for the leaf templates). Position the blank MDF leaf shapes onto the frame and draw around them using a piece of chalk to mark their positions (see Tip below).

2 Tile the leaves individually, making each one slightly different. Dark green and brown mini tiles cut into thin strips down the centre of the leaf and outwards towards the edges help define the leaf veins. Make these strips by dividing the mini tiles into thirds or quarters (see page 17) gluing them neatly into flowing lines. Use micro tiles to fill in the leaves to the edges, cutting them where necessary to fit the shapes. Use two different coloured greens on each leaf, a darker and lighter tone, to give the impression of light and shade and add to the three-dimensional quality. Tile all 14 leaves, mixing the greens so that no two are exactly the same, and then leave to dry.

Tip WHEN DECIDING ON YOUR DESIGN FOR THIS FRAME, USE A GOOD MIX OF LARGE AND SMALL LEAF SHAPES (SEE PICTURE, RIGHT) TO ENSURE THAT THE DESIGN IS INTERESTING, BALANCED AND PLEASING TO THE EYE.

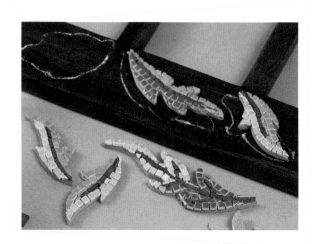

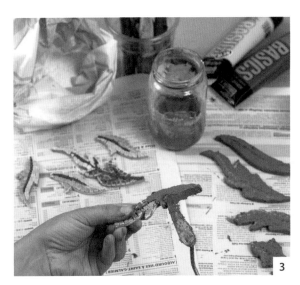
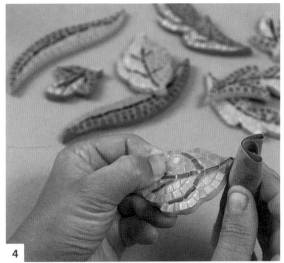

3 Spread your work area with newspaper to protect it from the grout and then grout the leaves with grout that has been coloured with green acrylic paint (see page 24 for instructions). Mix up several different shades of grout so that some of the leaves will be darker than others. Remember to take the grout right over the edges to seal the gap between the tiles and the wood.

4 Once the grout has set lightly, sand around the edges of the leaves with fine-grade sandpaper to give them all a smooth finish. Sand off any residual grout too from the bottoms of all the leaves so that the backs are nice and smooth and will then sit flat on the picture frame.

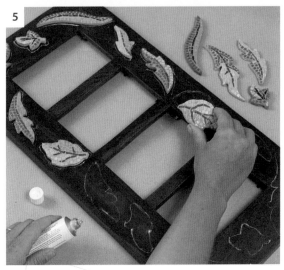

5 Using polyurethane adhesive set the leaves into their positions on the frame, placing them securely in the spaces indicated by the chalk lines you marked in step 1.

Tip THIS PICTURE FRAME CAN BE HUNG IN A LANDSCAPE (WIDE) OR PORTRAIT (TALL) STYLE TO FIT ANY SPACE. THESE MOSAIC TILES WILL NOT FADE OR DEGRADE IN SUNLIGHT MAKING THE FRAME AN EXCELLENT CHOICE FOR A CONSERVATORY WALL SURROUNDED BY LUSH GREEN PLANTS.

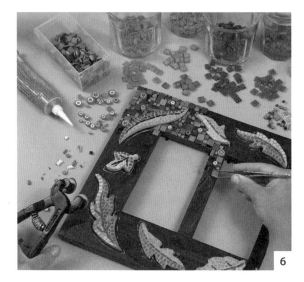

6

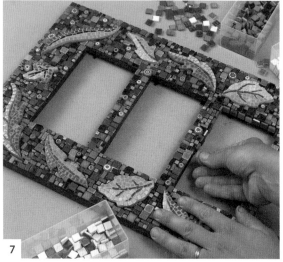

7

8

6 Tile the background around the leaves using a large palette of tile colours and beads. The background should be tiled in a disciplined way using squares and rectangles of varying sizes, fitted tightly together. Work on a small area at a time adding more glue as you go. Start at one corner and work systematically across and down the frame (see Tip below). Tile the central struts that separate the cut-outs and fill the entire frame right to the edges.

7 Once the top of the frame is completely dry you can start to tile the inner edges of the frame, where the glass is recessed, with whole mini tiles in neat lines.

8 Tile the outer edges of the frame with standard 2cm (¾in) whole tiles in a mixture of vitreous glass and ceramic finishes.

Tip TILING FROM ONE CORNER AND WORKING ACROSS AND DOWN THE FRAME WILL PREVENT YOU FROM ACCIDENTALLY DISLODGING ANY PREVIOUSLY TILED AREAS BY STRETCHING OR LEANING OVER TO REACH HIGHER UNTILED SECTIONS.

9

9 Carefully grout the background around the leaves in a grout coloured with dark brown acrylic paint (see page 24). Once the grouting is finished and dry attach two D-ring fittings to the back of the frame. Insert the glass and mounting board into the inserts along with your chosen photographs or art prints.

Tip YOU WILL NEED TO GROUT THE BACKGROUND VERY CAREFULLY, MAKING SURE THAT NONE OF THE BROWN GROUT ACCIDENTALLY SPLASHES ONTO THE GREEN LEAVES.

LEAF SCARF CLIP

If you want to make a leaf brooch or scarf clip, you could tile an extra leaf or two while you are making the frame or necklace. When the tiled leaf is finished and dry, use superglue to fix a brooch pin to the back – see picture 7 on page 71.

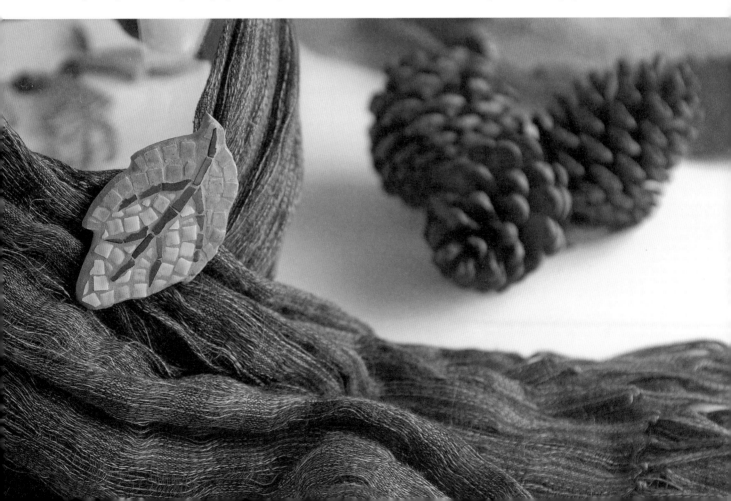

Leaves Necklace

This beautiful and unusual drop necklace is sure to attract attention. It is designed using three mosaic leaves that drape gently downwards, separated by pretty beads. Strung onto soft green cotton cord for comfort it is incredibly lightweight and has an organic look that would accentuate a simple strap dress or perhaps an elegant evening dress with a plunging neckline. A matching scarf clip is easily made using the same techniques – see the picture on the previous page.

You will need

MDF leaves
one 12cm (4¾in) long and two 7cm (2¾in) long, or a piece of 3mm (⅛in) MDF 10 x 14cm (4 x 5½in)

Mini glazed ceramic tiles
in dark green

Micro glazed ceramic tiles
in pistachio green, olive green, light green and turquoise green

2 large green beads

4 wooden beads
6mm (¼in) square

12 round wooden green beads

4 metallic square beads 3mm (⅛in)

Green cotton cord
70cm (27in) long, with two spring ends 2mm (1⁄16in), jump rings and a silver lobster clasp 1.25cm (½in)

Clear varnish

PVA (white) adhesive

Green grout
(see page 24)

Green acrylic paint

Making time: 3–5 hours

Drying time: 20 minutes–1½ hours

Weight: 50g (1¾oz)

THIS STUNNING NECKLACE IS SURE TO BE A TALKING POINT. THE SHADES USED COULD BE CHANGED TO SUIT YOUR OWN COLOUR PREFERENCES.

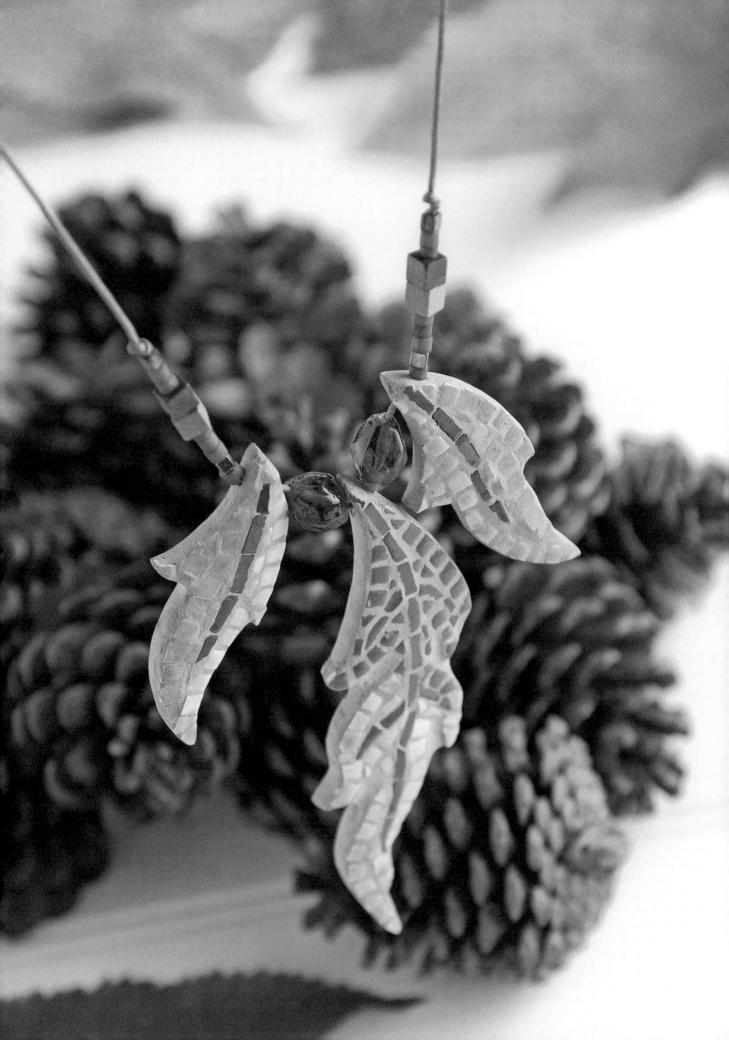

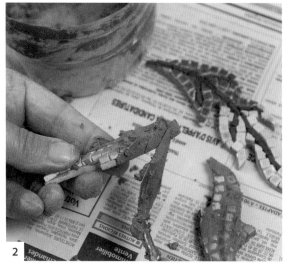

1

2

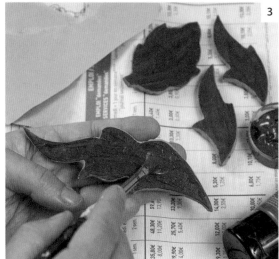

3

1 If you are not using pre-cut MDF leaf shapes, sketch or trace and transfer the leaves onto a piece of MDF and then cut out with a scroll saw (see page 120 for templates). Using the PVA (white) adhesive, tile the leaves carefully cutting the mini dark green tiles for the central veins and two tones of green for the foliage (see step 2 of the photo frame project on page 64). Use whole micro tiles wherever possible, cutting them only to fit the remaining gaps.

2 Mix up a small amount of grout coloured with green acrylic paint (see page 24) and grout the leaves (see step 3 of the photo frame project on page 65) but for this project use the same colour green grout for all the leaves to ensure a perfect match. Once the grout is dry remove any excess or residual grout on the edges or backs of the leaves by lightly sanding them. Polish them with a clean soft cloth and some household polish.

3 Paint the backs of the leaves with green acrylic paint and leave to dry fully. Once dry, apply a layer of clear varnish to finish the backs.

Tip APPLYING A LAYER OF CLEAR VARNISH TO THE BACK OF THE LEAVES WILL GIVE THEM A SHINY, WATERPROOF FINISH. THE VARNISH WILL PROVIDE EXTRA PROTECTION FROM MOISTURE AND SEAL THE PAINT PERMANENTLY ONTO THE WOOD.

4

5

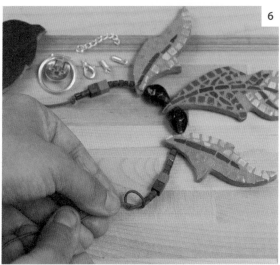
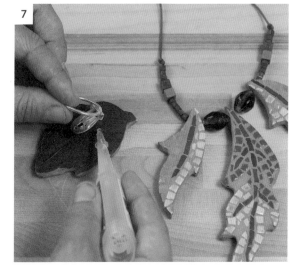

6

7

4 Make the threading hole 1cm (⅜in) from the tip of the leaves by drilling a small hole, using a fine 2mm (¹/₁₆in) drill bit, as shown.

6 String a few more smaller wooden and metallic beads onto the cord. Knot the cord on each side just after the last bead, to stop the beads moving about and to separate the leaves when the necklace is worn.

7 Finally, assemble the necklace clasp and ends (see page 27) to the cord. A scarf clip glued to the back of an alternative leaf shape (as shown in picture 7) will make an excellent matching accessory – see page 67 for a picture of the finished scarf clip.

5 Thread the cord through the central leaf until it sits in the middle of the cord. Now add a large separating bead onto each side before attaching the two smaller leaves (see Tip below).

Tip PLACING A LARGE BEAD BETWEEN THE LEAVES WILL KEEP THEM SPACED APART SO THAT THEIR FULL EFFECT CAN BE SEEN CLEARLY AND THEY DO NOT OVERLAP. IF YOU DO NOT WISH TO ADD ANY EXTRA BEADS TO THE END CORD ON EITHER SIDE OF THE OUTER LEAVES, SIMPLY TIE THE KNOT TIGHTLY UP AGAINST THE THREAD HOLE.

Giraffe Earring Board

Storing earrings can often be difficult, as in a jewellery box they can detach from their pair and often sustain damage through searching and rummaging. Instead of leaving them on dressing tables or shelves where they can get knocked off or hidden, it's nice to have a place to store and see them easily, allowing you to find them in an instant, and this hook board, in hot African savannah colours, is the perfect place.

You will need

Piece of 9mm (⅜in) plywood
 18cm (7in) square

6 standard vitreous glass tiles 2cm (¾in)
 in black

Mini and micro glazed ceramic tiles
 in deep reds, copper, oranges, tans, browns and creams

13 gold-plated 8mm (⁵⁄₁₆in) diameter eyelets (self tapping)

Brown acrylic paint

Brown grout (see page 24)

PVA (white) adhesive

2 picture hanging hooks and screws

Making time: 5–7 hours

Drying time: 20 minutes–2 hours

Size: 18cm (7in) square

THIS MOSAIC EARRING HOOK BOARD CAN BE HUNG IN EVEN THE SMALLEST BEDROOM AND AS WELL AS FULFILLING A PRACTICAL ROLE IT ALSO LOOKS GREAT AS A MOSAIC ARTWORK. THE HOOKS ARE EMBEDDED INTO THE MOSAIC BACKGROUND SO THAT THEY ARE ALMOST UNNOTICEABLE.

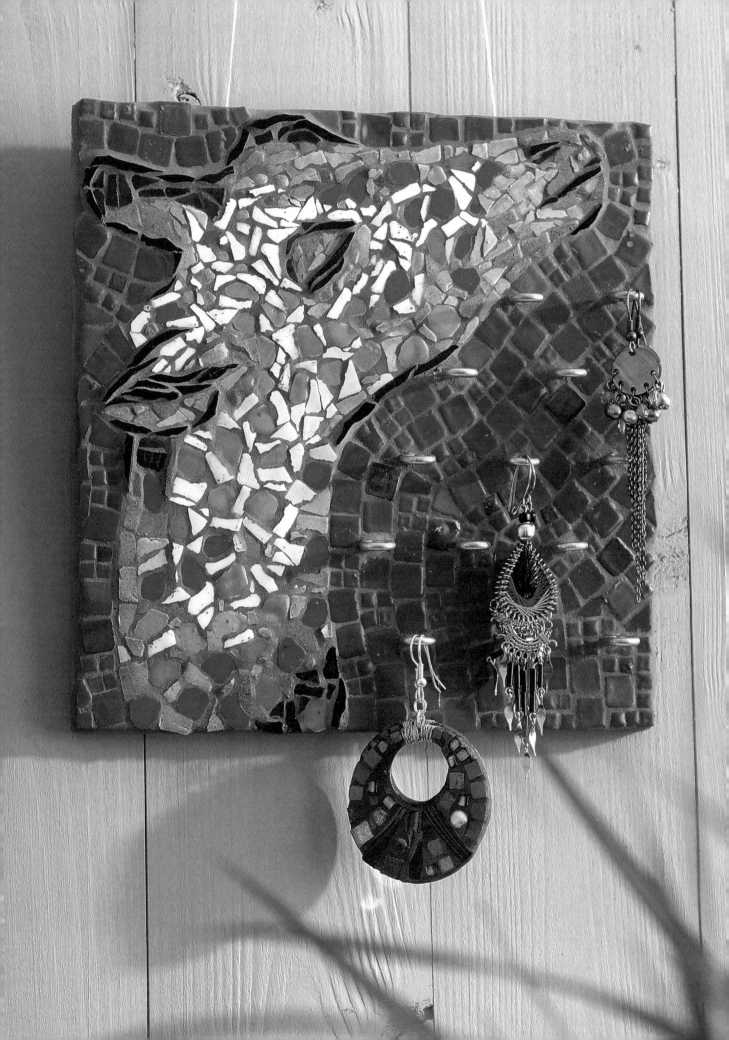

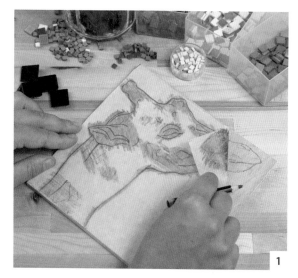

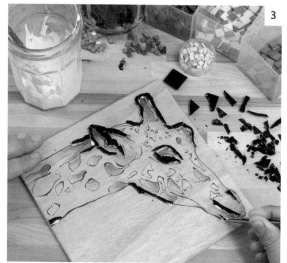

1

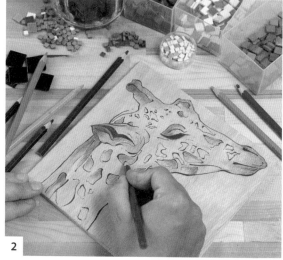

2

3

1 Using the template on page 121, sketch or trace and transfer the giraffe design onto the plywood and then darken the outline with pen or dark pencil (if required, see the instructions for tracing a design on page 110).

2 Roughly fill in some areas of colour with wax crayons or colouring pencils to define the shading and mark out the different coloured areas to be tiled.

3 Cut the black vitreous glass tiles into very thin strips (see tile cutting pages 17–19 and the Tips below and on the opposite page). Start with one long cut diagonally across the tile and then make another cut very close to the first one so that the tile will fracture close to the edge and form fine, thin pieces. Using the PVA (white) adhesive, set these pieces into position, framing the eyes and eyelids, ears, nose, mouth and the underside of the neck, as shown.

Tip USING FINE, THIN PIECES OF TILE TO FRAME AREAS OF A DESIGN WILL CREATE LINES THAT WILL GIVE CLARITY AND DEFINITION TO THE IMAGE.

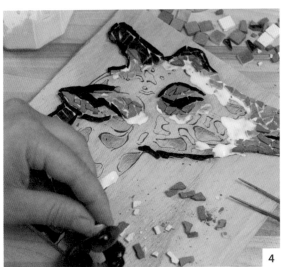
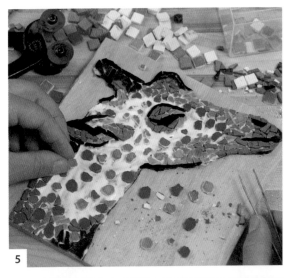

4 **5**

6

4 Now cut the mini brown ceramic tiles into randomly shaped pieces and shade the areas around the eyes, nose, ears and neck – darker browns create shadow whilst lighter browns highlight areas and give the features a more rounded quality.

5 To make the mottled orange spots on the giraffe round off the edges of micro and mini tiles by 'nibbling' the points away to create softer shapes (see page 18). These spots need to be random and rough though, not uniform, so make some elongated and have a good mix of light and dark spots to add depth and create a more natural effect.

6 Now fill in the rest of the giraffe's neck and head with the tan and cream tiles, which will give the impression of dappled light on the giraffe's skin.

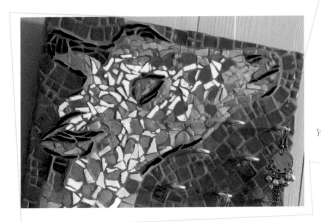

Tip ULTRA-FINE LINES CAN BE CREATED BY ANGLING YOUR HOLD ON THE WHEELED NIPPERS SLIGHTLY WHEN MAKING THE DIAGONAL CUTS ACROSS THE TILES. NIPPING AT A SLIGHT ANGLE WILL CREATE SOFT CURVED LINES AND DELICATE STRIPS, AS SEEN IN THE PICTURE, LEFT. PRACTISE TILTING THE ANGLE OF THE NIPPERS VERY SLIGHTLY TO MANIPULATE THE LINE SHAPES UNTIL YOU FIND A TECHNIQUE THAT SUITS YOU.

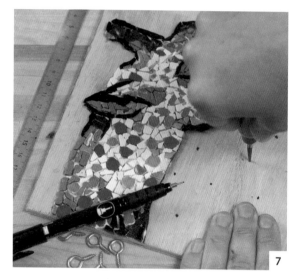

7

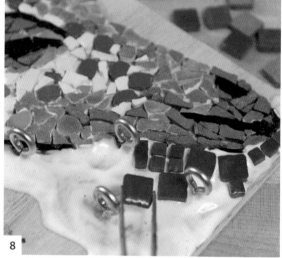

8

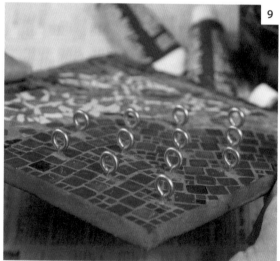

9

7 Mark out the positions for the eyelets into five
horizontal rows as given on the template on page
121. The eyelets should screw straight into the wood
with just a little pressure, however it is sometimes
easier and more accurate to make a small hole in the
wood first using an awl.

8 Tile around the giraffe and eyelets using deep red
mini and micro ceramic tiles intermingled with
flashes of copper tiles until the background is filled
(see Tips, left and below). Leave the piece to dry
completely.

9 Grout the mosaic with a powdered grout that
has been coloured with brown acrylic paint
(see page 24), taking the grout over the edges to fill the
gap between the wood and the tiles. Leave the grout to
dry completely and then lightly sand around the edges
with fine-grade sandpaper to create a smooth finish.
A tidy edge will frame the mosaic and give a more
professional finish.

Tip USING MICRO TILES WILL ENABLE
YOU TO FILL IN ALL THE SPACES AROUND THE
EYELETS VERY EFFECTIVELY WITH MINIMAL
CUTTING OF TILES.

Tip THE OPUS MUSIVUM PATTERN IS CREATED WHEN
OPUS VERMICULATUM (SEE TIP ON PAGE 47) IS EXTENDED
AND REPEATED SO THAT THE ENTIRE AREA IS FILLED. USING
OPUS MUSIVUM FOR THE LEOPARD BACKGROUND MAKES
THE PIECE EXTREMELY LIVELY AND DYNAMIC.

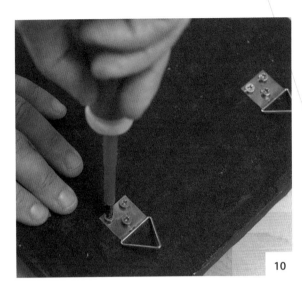

10

Tip USING TWO PICTURE FITTINGS RATHER THAN ONE WILL ENSURE THAT THE BOARD CAN BE SECURED FIRMLY TO THE WALL, ELIMINATING ANY POTENTIAL MOVEMENT NO MATTER HOW MANY EARRINGS ARE HUNG AT ANY ONE TIME.

10 Apply a layer of brown acrylic paint to the back of the board and allow to dry before attaching two picture hanging fittings, making holes for the screws with an awl.

LEOPARD NECKLACE BOARD

Made with mini and micro glass and ceramic tiles this leopard necklace board has a gold rail on which to hang earrings or bracelets and three hooks at the bottom for necklaces. Dark brown grout helps to outline the leopard with a silhouette-like quality. Using bright orange mini ceramic mosaic tiles for the background, tiled using opus musivum (see Tip opposite), the surrounding mosaic accentuates the leopard's powerful stance and gives the artwork a sense of anticipation. The template for this design is on page 122.

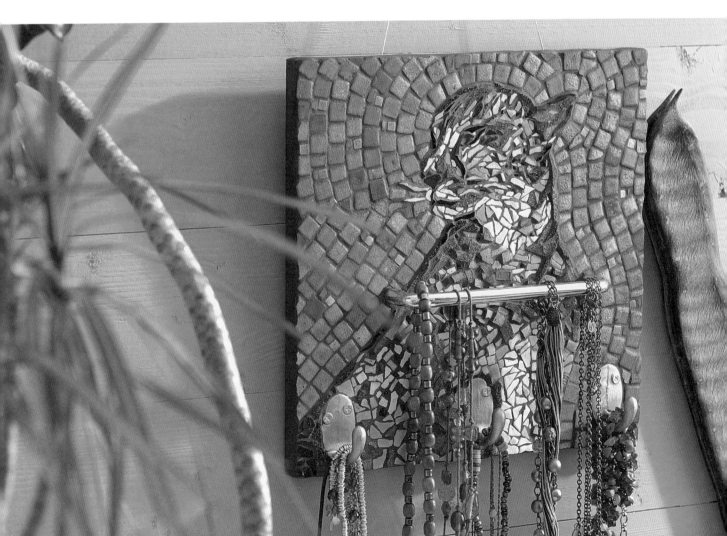

Safari Pendant

Evoking the spirit of the Serengeti, that vast and ancient tract of land in Africa, this jewellery is designed to be worn simply with a natural cotton T-shirt or against lightweight khaki clothing. The colour scheme is a combination of warm browns, ochre, sepia, burnt sienna and raw umber, spiced up with deep chocolate and copper elements. Made on a lightweight wooden base, the pendant has small holes drilled at intervals from which additional bead strands can be suspended.

Making time: 2–4 hours
Drying time: 20 minutes–1½ hours
Weight: 30g (1oz)

THE HOT COLOURS AND TRIBAL LOOK OF THIS IMPRESSIVE PENDANT EVOKE AFRICA IN ITS MANY MOODS.

You will need

Piece of 3mm (⅛in) plywood
10cm (4in) square

Glazed and unglazed ceramic micro and nano mosaic tiles
in muted earth and stone tones

23 metallic/gold/copper beads
3mm (⅛in) square

Standard 2cm (¾in) vitreous glass gold-threaded tiles
in mahogany, copper and chocolate

4 round wooden beads 8mm (⁵⁄₁₆in)
with abstract pattern

4 matt wood beads 6mm (¼in) square
in brown and russet tones

4 round 5mm (³⁄₁₆in) beads
in gold and amber

3 gold 11° seed beads

4 silver-headed pins 5cm (2in)

Silver wire 1mm thick,
turned into 5 loops each 1cm (⅜in) diameter (see page 26)

2 spring ends 2mm (¹⁄₁₆in) and a silver lobster clasp 1.25cm (½in)

Black leather cord thonging 2mm (¹⁄₁₆in) diameter x 40cm (15¾in)

Brown acrylic paint

Brown grout (see page 24)

Clear wood varnish

PVA (white) adhesive

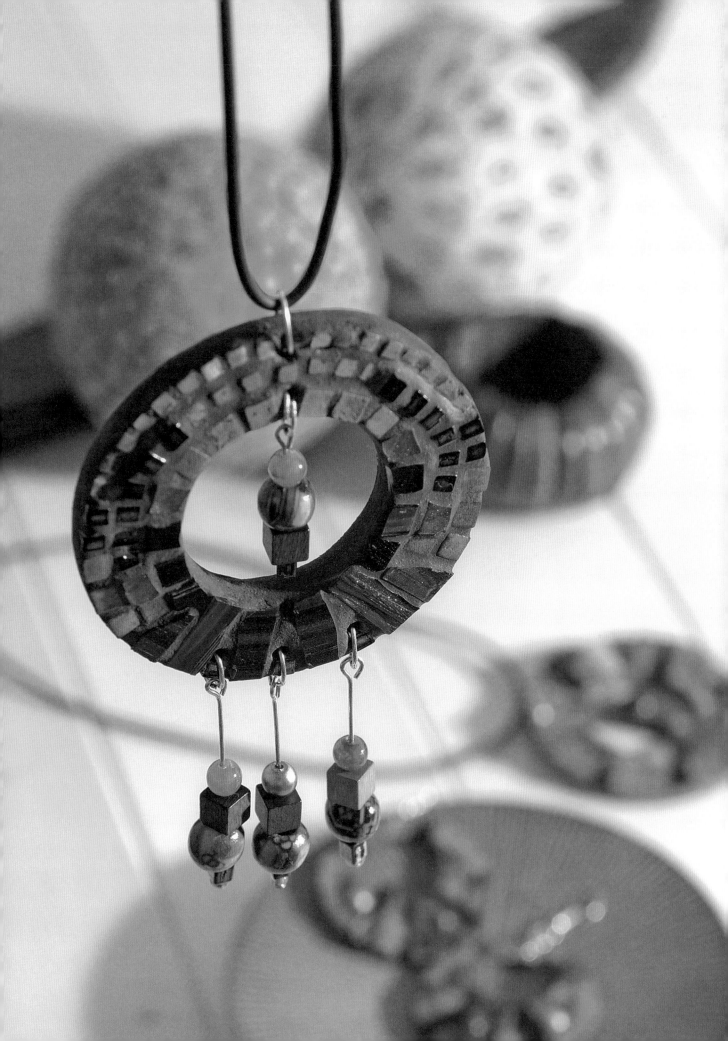

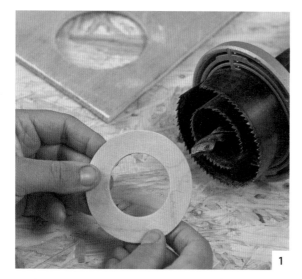

1

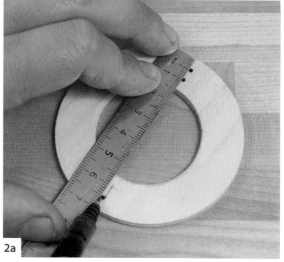

2a

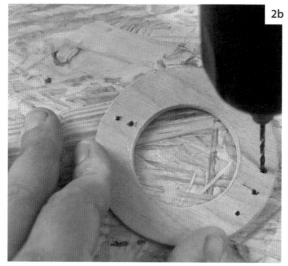

2b

1 A diagram of this design is given on page 120 if required. Mark out a 3.5cm (1¼in) diameter circle onto the plywood – this will form the inner hole of the pendant. Using the same centre, mark out another larger circle around the original at a diameter of 6.5cm (2½in) – this forms the outer circumference of the pendant. Using a drill fitted with a 6.5cm and 3.5cm hole saw bit, cut out the circles as shown. You will be left with a wooden ring that has a width of 1.5cm (⁹/₁₆in) all the way around.

2 To mark the holes for the hanging bead strands start by marking two holes directly above one another for the central beads and thong fitting at 5mm (³/₁₆in) from the outer edge and 5mm (³/₁₆in) from the inner edge of the circle. Moving down to the bottom segment mark the first of the three holes for the long bead strands down in a straight line from the top two holes again at 5mm (³/₁₆in) from the outer edge of the circle (2a). The final two holes are marked at 1cm (³/₈in) intervals either side of this central hole. Drill out these holes using a fine 1.5mm drill bit (2b). Using fine-grade sandpaper, lightly sand around the drilled holes and edges to remove any splinters. Apply a layer of a solution of PVA (white) adhesive (one part PVA to five parts water) to seal the surface. Leave to dry.

Tip TO SET THE COMPASS AT AN ACCURATE DISTANCE PLACE THE POINT OF THE COMPASS ON A RULER AT 0 AND THE LEAD OF THE PENCIL AT 6.5CM (2½IN) AND THEN MAKE SURE THAT THE HINGE AT THE TOP OF THE COMPASS IS TIGHTENED SO THAT IT DOES NOT SLIP. TIGHTEN THE HOLD FOR THE PENCIL SO IT IS HELD FIRM. PRESS THE NEEDLE DOWN FIRMLY AND TURN THE KNOB AT THE TOP OF THE COMPASS TO CREATE THE CIRCLE.

Tip MICRO MOSAIC TILES ARE THE SAME SIZE AS STANDARD MOSAIC TILES THAT HAVE BEEN CUT INTO EIGHTHS, OR MINI MOSAIC TILES THAT HAVE BEEN CUT INTO QUARTERS. THE PENDANT USES A MIXTURE OF GLASS AND CERAMIC TILES CUT INTO PIECES THAT WILL INTEGRATE INTO THE DESIGN.

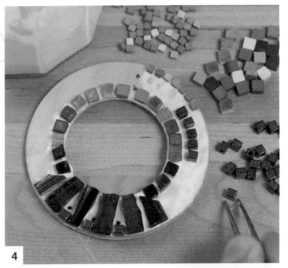

3 **4**

3 Cut two of the mahogany gold-threaded standard vitreous glass tiles in half to form rectangles and using PVA (white) adhesive set these in place evenly spaced between the three lower holes. Set three of the metallic copper beads in between these below the holes. Cut two more triangular pieces and place these next to the rectangles to complete this sector.

4 Sort the remaining tiles and beads into piles of similar-sized pieces then starting with the 5mm micro tiles complete a line around the central hole. Tile the final two lines evenly, gradually grading them upwards towards the top. Begin with the micro pieces reducing them, in a disciplined pattern, through the 4mm metallic square beads flowing into the smallest 3mm nano tiles at the top.

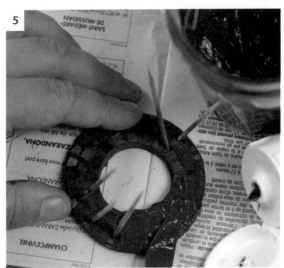

5

5 Mix a small amount of powdered grout with some brown acrylic paint and water to form a paste (see page 24) and grout the mosaic carefully. Grout the edges of the pendant to close the gap between the tiles and the wood. Place cocktail sticks into the holes whilst grouting to avoid filling them in. As this pendant has varying levels take care when removing grout to ensure that all tiles are revealed and no small elements remain undiscovered.

Tip WHEN USING BEADS AS TILES REMEMBER TO KEEP THE THREAD HOLES HIDDEN BY TILING THE BEAD LYING ON ITS SIDE. ONCE GROUTED THE SMOOTH SIDE OF THE BEAD WILL LOOK JUST THE SAME AS A MOSAIC TILE.

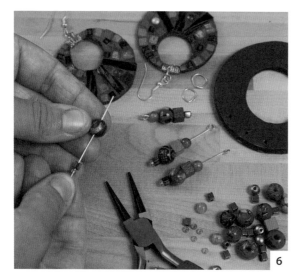

6

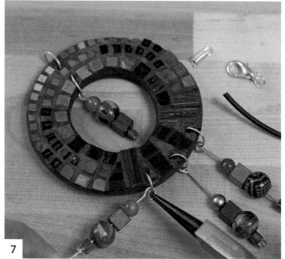

7

6 Paint the back of the pendant with brown acrylic paint. Once dry apply a layer of clear varnish to give a shiny, water-resistant finish. Leave to dry completely. Make the jump rings by turning the wire into loops 1cm (³⁄₈in) in diameter and threading them through the holes, as shown. Now make the four hanging bead strands. Place a small seed bead or metallic bead at the bottom of each one to keep the larger beads from slipping off the pin and then slide the larger beads on top.

7 Once threaded turn the tops of the three lower pin strands to form neat eyes (see page 26). Cut the centre strand pin shorter so that it fits into the hole and swings freely without touching the wood. Suspend these securely by twisting the eye closed tightly around the jump rings. Finally, assemble the necklace clasp and ends (see page 27) on the thonging and attach the pendant through the remaining jump ring.

Tip IT IS BEST TO MAKE A PAIR OF EARRINGS OR OTHER MATCHING ACCESSORIES SIMULTANEOUSLY. THE EARRINGS WILL NEED TO BE EITHER IDENTICAL OR A MIRROR IMAGE OF EACH OTHER AND ALTHOUGH IT IS IMPOSSIBLE TO MAKE TWO EXACTLY THE SAME, TILES PLACED IN A SIMILAR PATTERN AND SPACING WILL LOOK ALMOST THE SAME WHEN WORN.

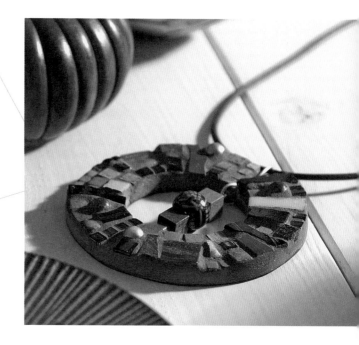

AFRICAN PENDANT AND EARRINGS

Continuing the deep, earthy theme the pendant shown here (below, opposite) has been made without the lower bead strands. It uses a variety of different sized micro and nano mosaic tiles interspersed with 1cm (⅜in) resin tiles and beads. The beads are set randomly into the pattern to vary the surface texture, giving the piece an interesting tactile quality. The changing levels across the circle help it catch the light from different directions. Diagrams are given on page 120 if required.

The earrings are made on a 1mm thick, flat silver base and are 4.5cm (1¾in) in diameter. A 2cm (¾in) hole, this time closer to the top of the circle, allows for larger pieces of tile to be placed in the lower sector of the earrings distributing the weight of the design downwards. Lighter micro and nano ceramic tiles have been graded up towards the top in an asymmetric pattern. The earrings are finished with some silver wire windings around the jump ring fastening. These could easily be adapted from pierced to clip-on fittings by using the findings shown on page 12.

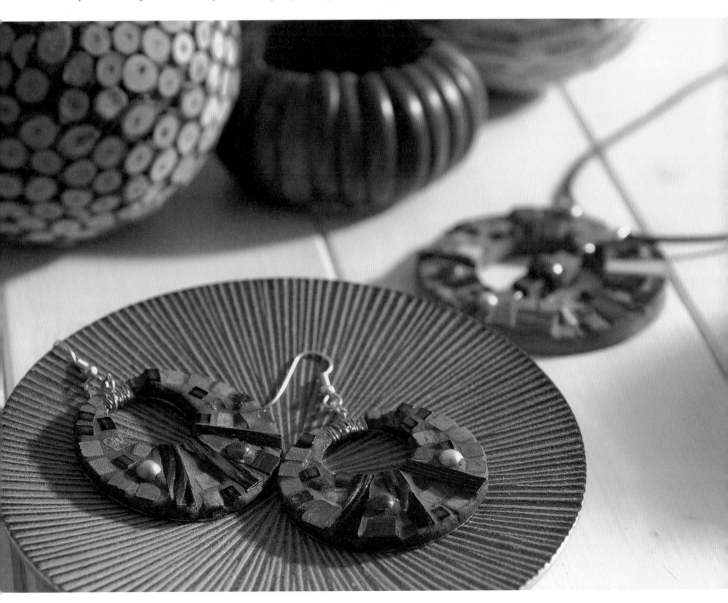

Floral Lotions Bottle

Add a touch of class to your dressing table or bathroom by transforming a plastic liquid dispenser into a stylish soap or cleanser container. Plain plastic pots are inexpensive and can be used for mouthwash, make-up remover or hand lotion. Why not tile several pots, varying the flower colour to indicate different contents? The white and turquoise colour scheme has a light, fresh feel and copper lines define the flower edges. The millefiori beads and micro tiles in the background could be toned with towels or room décor. Once finished it is waterproof and can be cleaned easily.

You will need

Tapered, clear plastic soap dispenser
11.5cm (4½in) tall and 7cm (2½in) wide at the top, with a removable chrome pump

Mini ceramic tiles
in white and copper

Micro ceramic tiles
in light turquoise, dark turquoise, copper and bright yellow

Millefiori glass beads 4mm (⅛in) and 6mm (¼in)
in a mixture of turquoise and yellow patterns, opaque and transparent

Black permanent marker pen

Polyurethane glue

White grout
(see page 23)

Turquoise blue felt 8cm (3in) square

Making time: 3–5 hours
Drying time: 20 minutes–2 hours

ADD A TOUCH OF LUXURY TO THE BATHROOM OR BEDROOM WITH PRETTY MOSAIC CONTAINERS. THE FLOWER MOTIF CAN BE REDUCED OR ENLARGED TO FIT ANY SIZE OF CONTAINER AND ENSURES THAT THE INDIVIDUAL ITEMS STAY COORDINATED.

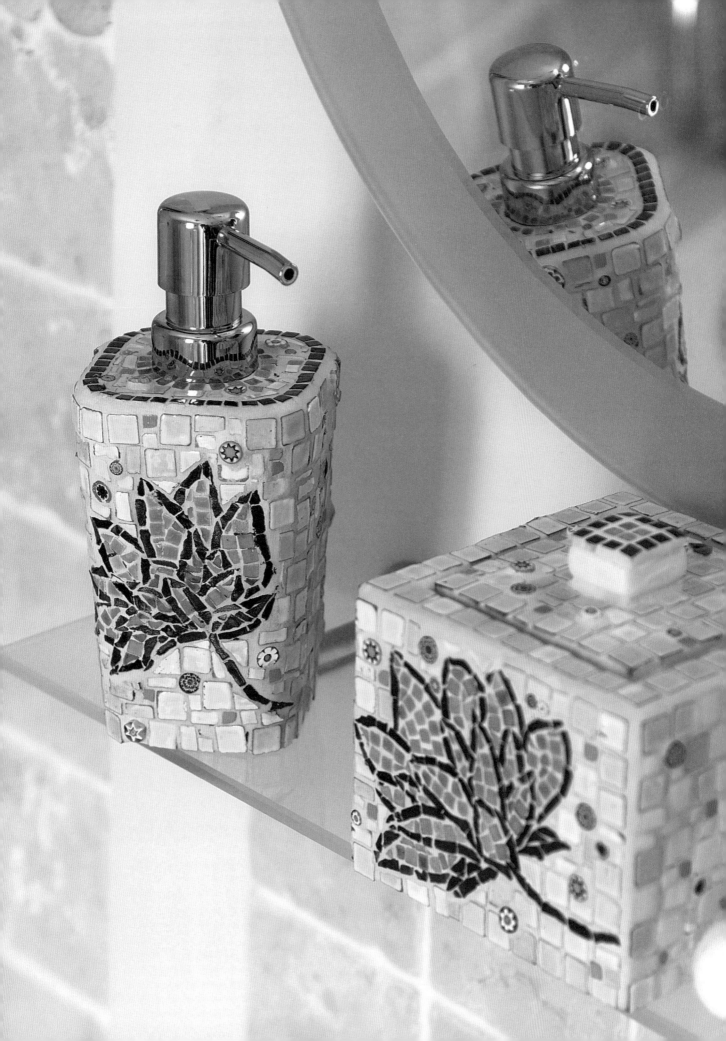

1

2

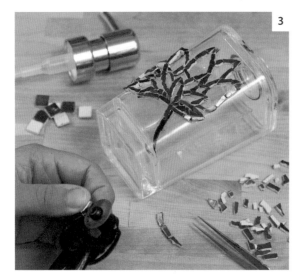
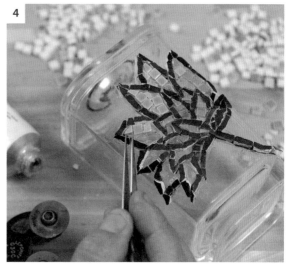

3

4

1 Draw the flower onto the front of the plastic dispenser using a thick, permanent marker pen. Alternatively, trace the design from the template on page 123 onto tracing paper and cut around the outer edge of the design and glue the flower firmly to the pot; you can then tile directly over the paper flower. Once the design is transferred draw a line around the chrome pump section before removing as shown. This will provide a guideline on the container top to tile up to and marks the edge of the area to be tiled, ensuring that you leave enough of a gap to re-attach the pump.

3 Use polyurethane glue to tile the outlines for the flower and petals with long lines of copper mini tiles divided into thirds or quarters (see page 17). As the pieces are small hold the tiles firmly between thumb and forefinger either side of the nippers for a good grip. Fill the bottom two petals with copper tiles as this will give the bloom weight at the bottom and extra clarity.

2 Whilst the pot is still clean mark out a square of felt for the bottom of the dispenser. This will give you the option of a non-scratch base if the pot is placed on a delicate surface. Put the felt aside along with the chrome pump.

4 Using micro ceramic tiles in two shades of turquoise fill in the rest of the petals as shown. To make a more rounded and realistic flower use the darker turquoise for the lower petals and the lighter turquoise for the tips. Cut the tiles where necessary to fit the spaces tightly. You will be able to use whole micro tiles in some of the larger petals.

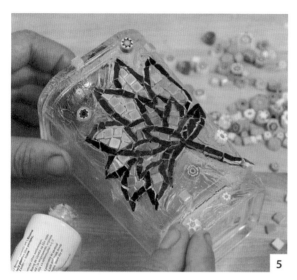

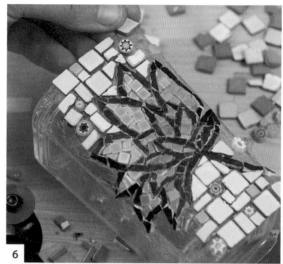

5 Sort and select some turquoise and yellow millefiori beads in varying sizes and patterns to 'dot' randomly into the background of the pot along with a few whole micro yellow tiles. These will break up the white background and add a pretty, raised dimension to the three plain sides.

6 Tile the rest of the background around the beads and flower and the other three sides with white ceramic tiles cut to fit around the shapes as necessary.

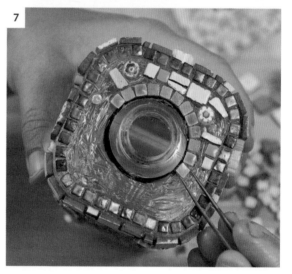

7 Tile the top of the pot with a row of micro copper tiles around the outside edge and a row of mixed turquoise tiles at the inner edge, just touching the marker line. In between put a mix of white mini tiles, millefiori beads and yellow micro tiles to match the pot sides. Grout with white grout. Fill with the liquid of your choice and reattach the pump top. Stick the felt base to the bottom for a scratchproof finish.

COTTON WOOL POT

This pot has been tiled in the same flower motif, enlarged slightly to fit the pot front. It measures 11cm (4¼in) square and has a ceramic base. The lid has been tiled separately as it lifts off. A toothbrush tumbler or soap dish would also make excellent coordinated accessories. The template for this design is on page 123.

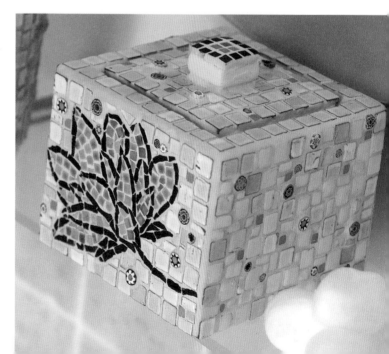

Rose Luggage Tags

Experienced travellers know that customizing your luggage eases the task of recognizing your case on airport carousels. These tags will personalize your luggage and give it an individual style without adding any extra weight – each tag weighs just 15g (½oz). Made with ultra-thin resin tiles on a slim wood base and finished with strong red leather thonging, they are virtually indestructible. These mosaic tags will ensure that absolutely no-one else will ever have the same labels as you! A matching key ring would make a great handbag accessory to complete the set – see page 91.

You will need

Mini resin mosaic tiles
in pinks, greens and white

2 plywood luggage tags
3mm (⅛in) tapered 4.5 x 8cm
(1¾ x 3in), with 3mm (⅛in) drilled hole

Red leather thonging
3mm (⅛in) wide, two 50cm
(20in) lengths

PVA (white) adhesive

Pink grout
(see page 23)

Pink gloss paint

Making time: 1–2 hours each
Drying time: 20 minutes–1½ hours
Weight: 15g (½oz) each

THESE CHARMING LUGGAGE TAGS ARE ULTRA LIGHTWEIGHT AND WILL ADD A DASH OF STYLE TO ANY BAGGAGE. RESIN TILES CAN BE CUT WITH SCISSORS, MAKING THEM SAFE FOR CHILDREN AND AN EXCELLENT PROJECT FOR ALL THE FAMILY.

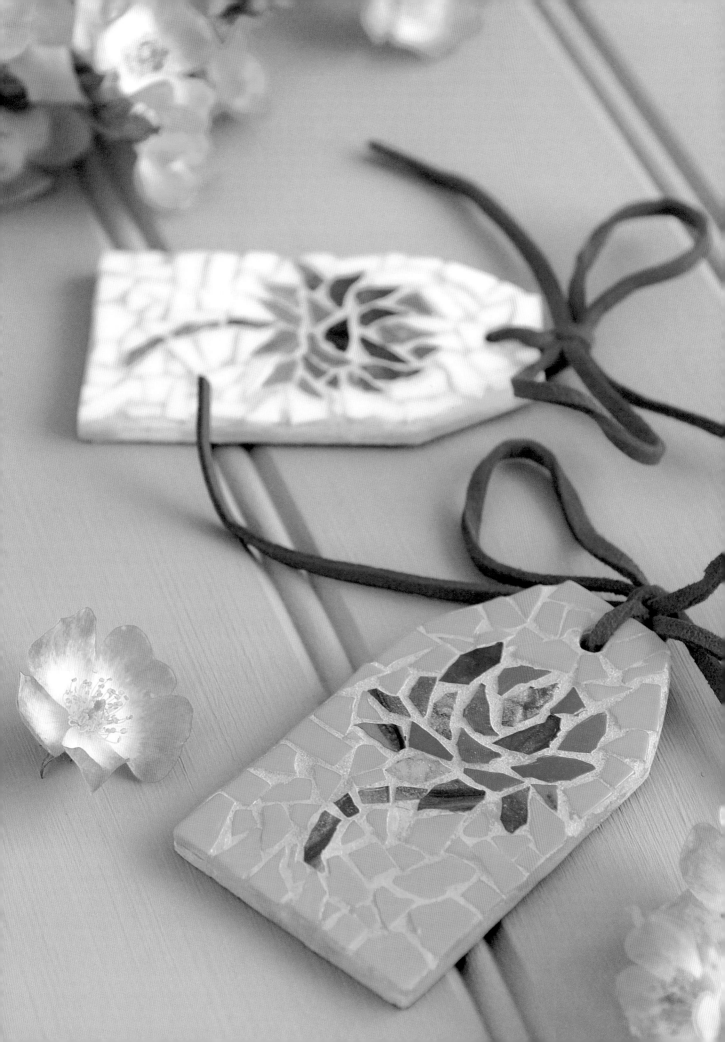

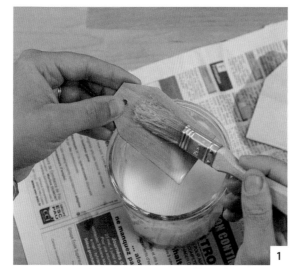

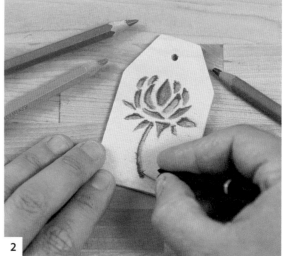

1 **2**

3 **4**

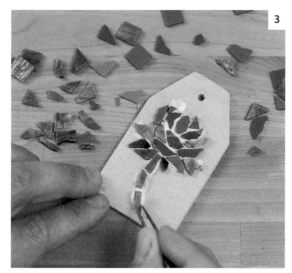

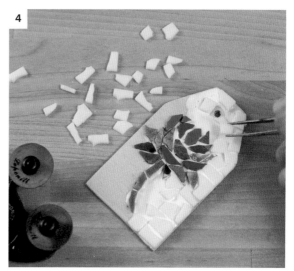

1 Seal one side of the plywood tags by brushing all over with a solution of diluted PVA (white) adhesive (one part PVA to five parts water). Leave to dry. Repeat this process on the reverse side of the tags and brush the sides too. Leave to dry completely.

2 Using the templates on page 122 sketch or trace and transfer the rose motif onto the wood (see page 110). Colour in the different elements of the design with colouring pencils.

3 Create the rosebuds by cutting pink tiles into triangular half pieces (see page 17). Round off the edges to form a softer petal shape by 'nibbling' at any harsh points on the two shorter sides of the triangle (see page 18). Position these to form an interlocking petal shape. Use a mixture of metallic and plain resin tiles to give extra shimmer and depth. Cut leaves and stems carefully from green tiles, keeping pieces evenly spaced and sized, using a mix of tiles in different finishes.

Tip SEALING THE TAG WITH DILUTED PVA WILL MAKE IT WATERTIGHT, FOR THOSE MOMENTS WHEN CAUGHT IN RAIN.

4 Tile the background with randomly nipped pink or white tiles. Try to pack the tiles neatly around the outside of the rosebud and stem so that you can fit some of the background colour all the way around the edge of the motif. Leave to dry completely.

 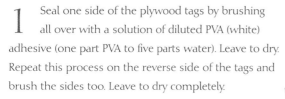 Hearts and Flowers

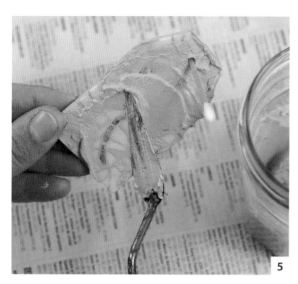

5 Mix up a small amount of pre-coloured grout
 and grout the mosaic, remembering to take the
grout over the edges of the tag to seal the gap between
tiles and wood. Place a cotton bud in the drilled hole to
stop it filling up with grout. Once dry, paint the back of
the tag with pink gloss paint to seal the surface.

6 To finish, thread the red leather thonging through
 the hole until the tag is resting in the centre.
Tie into a neat bow at the top of the tag leaving the rest
free to secure tightly to your luggage.

Tip USING GLOSS PAINT TO SEAL THE TAG
BACK WILL ALLOW ANY PRINTED STICKERS YOU
USE AS LABELS TO BE REMOVED. SIMPLY PEEL OFF
THE OLD LABEL AND PRINT A NEW ONE FOR EACH
JOURNEY. IF ANY STICKY RESIDUE IS LEFT WASH IT
OFF OR USE A SOLVENT CLEANING SOLUTION.

HEART KEY RING AND MOBILE PHONE CHARMS

A charming heart key ring has a
large red glass gem bead in the
centre surrounded by millefiori
heart-patterned beads of various
sizes. It is edged with metallic
gold square beads. The mobile
phone charms are made in a
similar pattern and finished
with golden yellow grout. Quick
and easy, they can be made in
minutes as there is no cutting
required. Templates for these
designs are on page 122.

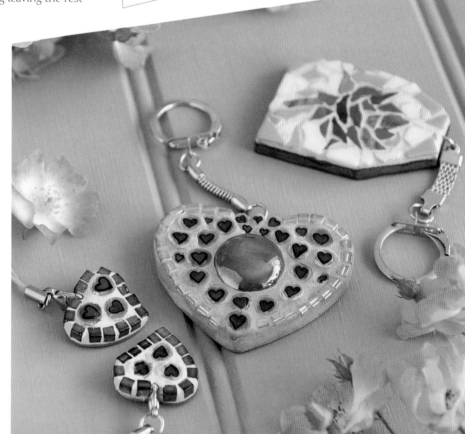

Scallop Shell Sarong Clip

Whether you wear your sarong as a halter dress, a wrap-over skirt or pleated at the front, you can add a little flair to all the styles by securing it with this attractive scallop-shaped clip. It has been tiled with rows of tiny sea shells separated with little pieces of ceramic and glass mini tiles. It is large enough to cover a knot of sarong fabric at the hip and also looks great pinned to a beach bag when not in use.

You will need

Pre-cut MDF scallop shell shape
 or a piece of 6mm (¼in) MDF
 9cm (3½in) square

40 small flat, spiral shells

4 small pointed shells

Mini vitreous glass and ceramic tiles
 in oranges

PVA (white) adhesive

Olive green grout
 (see page 23)

Waterproof paint or varnish

Scarf/sarong clip ring 2cm (¾in) long

Strong polyurethane gel glue

Making time: 1–4 hours

Drying time: 20 minutes–1½ hours

Weight: 50g (1¾oz)

THE RAISED SURFACES OF THE TINY SHELLS USED ON THIS SARONG CLIP GIVE IT AN ALLURING AND TACTILE QUALITY – THE PERFECT ORNAMENT FOR A BEACH HOLIDAY.

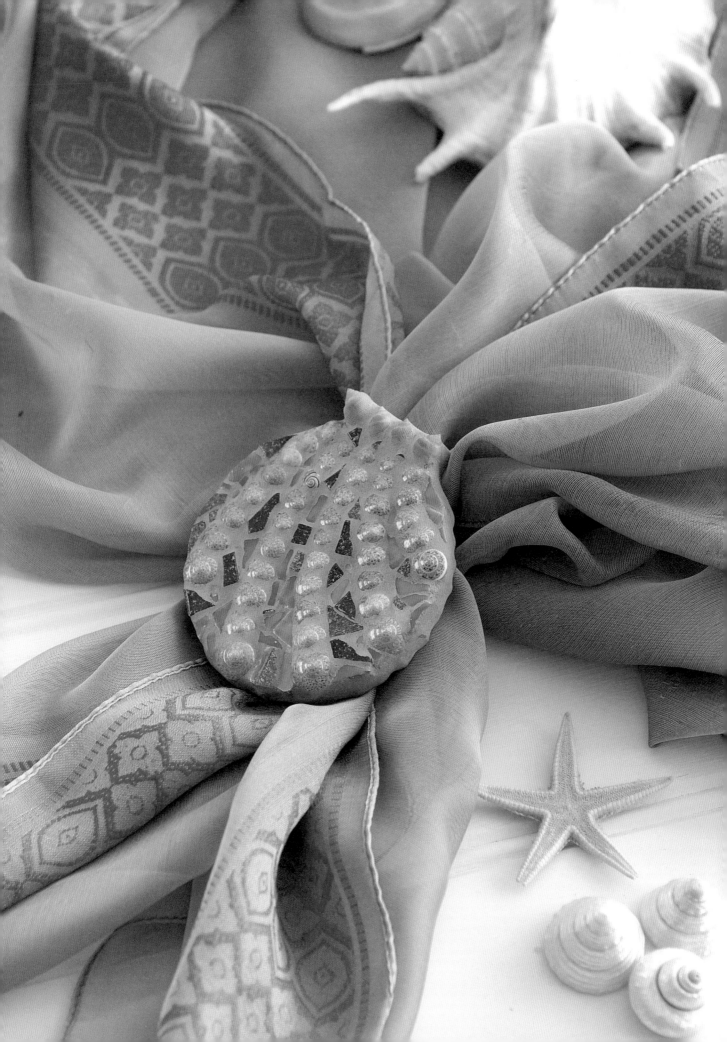

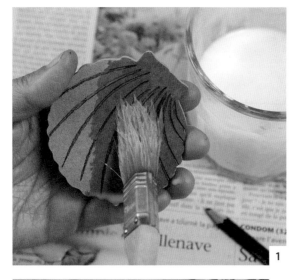

1

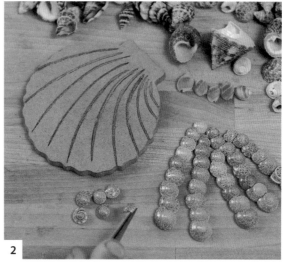

2

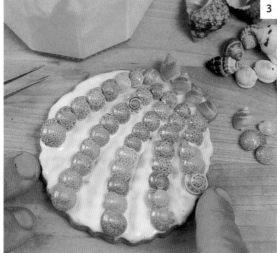

3

1 If you are not using a pre-cut MDF shell shape, trace the template on page 123 and then transfer the shell onto the piece if MDF, cut out with a scroll saw. Sand the edges smooth and mark out some lines with a pencil to use as a guide when tiling. Seal the wood shape all over by brushing with a diluted solution of PVA (white) adhesive (one part PVA to five parts water) and leave to dry. Apply a further two coats, leaving to dry thoroughly between coats.

2 Select 40 similar flat, spiral shells to form the five lines of the scallop and grade them upwards from the bottom, using the larger shells at the base and the smaller shells at the top – this will give the design depth. Select four small spiral shells to form a line at the top of the scallop. Experiment with arranging the rows of shells on the table top first, moving them around until you are satisfied that you have them in the desired formation.

3 Spread a thick layer of PVA (white) adhesive over the surface of the wood and transfer the shells systematically from the table top to the wood in neat lines. Use tweezers to nudge them into an interlocking position and fit them tightly together.

Tip SEALING THE MDF BASE WITH DILUTED PVA ADHESIVE WILL ENSURE THAT IT IS WATER RESISTANT, SHOULD IT ACCIDENTALLY BE SPLASHED WITH WATER FROM THE POOL.

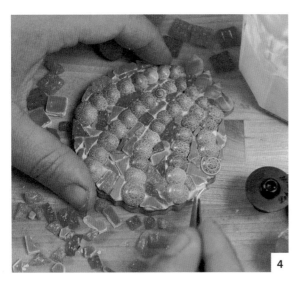

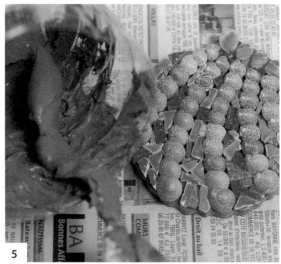

4

5

6

4 Cut mini vitreous glass and ceramic tiles into random shapes and tile up in between the lines. The contrast of the orange and pink tiles against the greeny grey of the shells will make the lines more prominent and mimic a real scallop shell. Tile right to the edges of the wood but be careful not to allow any tiles to protrude over the edge.

5 Allow the glue to dry completely before grouting with olive green grout (see page 23). Grout and clean the clip in the usual way (see page 25 and also the Tip here).

6 Paint the back of the wood with a layer of waterproof paint or waterproof varnish. Allow this to dry thoroughly and then use polyurethane glue to fix the clip to the back of the work.

Tip WITH THE MINUTE QUANTITIES OF GROUT NEEDED AND THE DELICATE NATURE OF THESE MINIATURE MOSAICS IT IS OFTEN EASIER TO MIX THE GROUT TO A MORE PUTTY-LIKE CONSISTENCY AND PRESS IT DOWN INTO THE GAPS BY HAND. BEFORE YOU START TAKE CARE THAT THE GROUT YOU ARE USING IS NOT CAUSTIC.

Nutmeg Shell Hair Slide

This attractive shell-shaped hair slide has been tiled with coloured mirror glass and a mixture of pointed shells in a range of sizes. The golden mirror glass is highly reflective so will glint in the sunshine. Bags of mixed shells can be purchased from many craft shops and suppliers. Making mosaics from shells that you have found on the seashore is great fun and an excellent excuse for a day trip to the beach!

You will need

Pre-cut MDF nutmeg shell shape
or a piece of 6mm (¼in) MDF
12 x 9cm (4¾ x 3½in)

Pointed spiral shells
in a range of sizes

Coloured mirror glass
in gold, amber and russet

PVA (white) adhesive

Light sandy yellow grout
(see page 23)

Golden yellow acrylic paint

Strong polyurethane gel glue

Nickel-plated hair clip
8cm (3in) long

Making time: 1–4 hours

Drying time: 20 minutes–1½ hours

Weight: 45g (1½oz)

WITH ITS GLOWING SUNSHINE COLOURS, THIS SHINY SLIDE MAKES A LOVELY HAIR ORNAMENT AND WILL BRING BACK SOME GREAT MEMORIES OF SUN, SEA AND SAND.

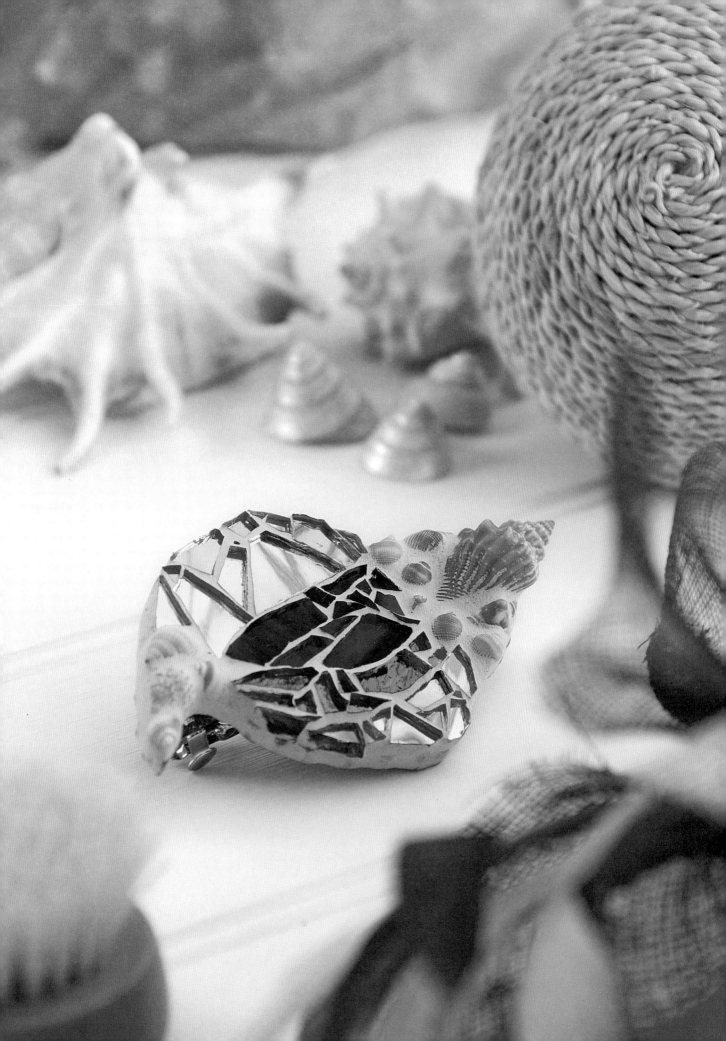

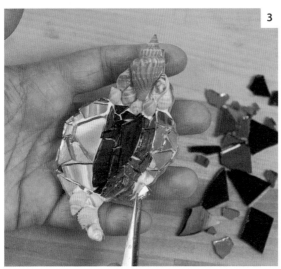
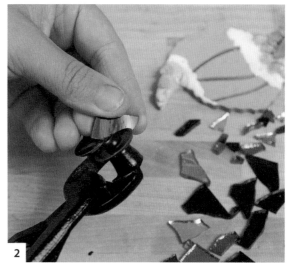
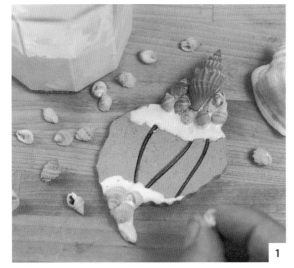
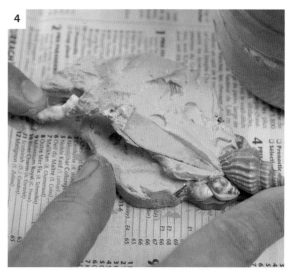

1 If you are not using a pre-cut MDF shell shape, trace the template on page 123 and then transfer the shell onto the rectangle of MDF. Cut out the shape with a scroll saw and sand the edges smooth. Mark out some lines with a pencil to use as a guide when tiling and then seal the wood shape all over by brushing with a diluted solution of PVA (white) adhesive (one part PVA to five parts water). Once dry, spread a thick layer of PVA adhesive over the top and bottom sections of the shell shape and select shells to use in these areas. Choose shells that are light in colour and tile them close together to form a cluster, setting them firmly into the glue. Make sure that they do not protrude over the edges of the wood.

2 Cut the mirror glass into small, randomly shaped pieces using tile nippers. Tile the centre strip of the shell with the darker russet glass and then tile a strip of amber-coloured glass alongside.

3 Tile the wider outer strips with the gold glass pieces and then leave to dry completely.

4 Grout the shell with a sandy yellow grout (see page 23). Using the pointed tip of a palette knife, scoop the grout carefully around all of the shells, making sure that all the gaps between the shells and the wood are filled (see page 25). Once dry, paint the back of the shape with yellow acrylic paint to seal it.

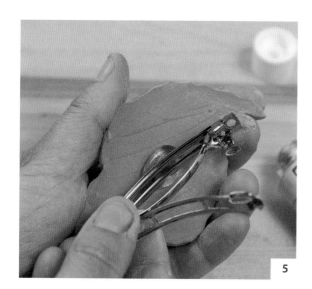

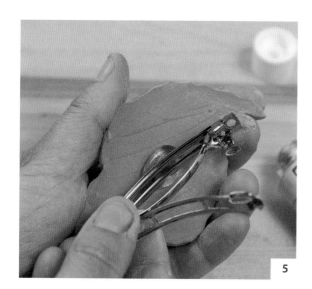

Tip WHEN REMOVING THE GROUT A COCKTAIL STICK OR TOOTHPICK MAY HELP TO CLEAN OUT SMALL AMOUNTS THAT REMAIN IN THE LINES OF THE SHELL'S SURFACE.

5

5 Attach the hair clip using strong polyurethane gel glue and leave to dry completely. This type of glue dries slowly so allow up to 24 hours before use.

STARFISH HAIR SLIDE AND CLIP

These attractive accessories are tiled with vitreous glass tiles layered into undulating lines to mimic waves. The use of Mediterranean blues and the extra sparkle of a glass gem bead will make even quickly scooped-up hair look stylish. Plain plastic or resin hair accessories can be customized easily this way and made to coordinate with beachwear. Templates for these designs are on page 124.

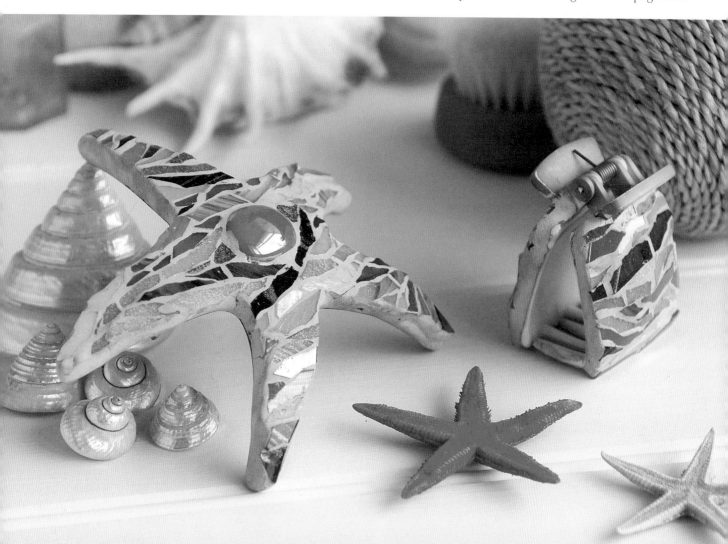

Zodiac Belt Buckles

Blank belt buckle bases are becoming very popular and are made in many shapes and finishes ready to be personalized with your own mosaic artwork (see Suppliers). Leather belts are available in all waist sizes and as the buckles are quick and easy to attach and detach, they can be changed according to your outfit. Three buckles are shown here with zodiac designs, tiled in a mixture of vitreous glass and ceramic tiles interspersed with millefiori and metallic beads. A rope frame encloses the mosaic and keeps the edges tidy.

You will need

Chrome/silver belt buckle blank
8 x 5.5cm (3 x 2⅛in)

Standard 2cm (¾in) black vitreous glass tiles

Mini vitreous glass and ceramic tiles
in white

Micro ceramic tiles
in black

Millefiori glass beads 4mm (⅛in) and 6mm (¼in)
in black and white patterns, opaque and transparent

42 silver beads 3mm (⅛in) square

Permanent marker pen

Polyurethane glue

Black grout
(see page 23)

Making time: 2–5 hours each
Drying time: 20 minutes–2 hours
Weight: 100g (3½oz) each

THESE BELT BUCKLES ARE STRIKING AND EASY TO MAKE. THE TAURUS SIGN IS IN A MASCULINE, COWBOY-STYLE ON A SILVER METAL RECTANGULAR BUCKLE BLANK. SCORPIO IS IN HOT, SANDY REDS ON AN ANTIQUE GOLD OVAL BUCKLE BLANK, WHILE ARIES IS TILED IN A MONOCHROME SCHEME. ALL 12 ZODIAC DESIGN TEMPLATES ARE GIVEN ON PAGES 124–125.

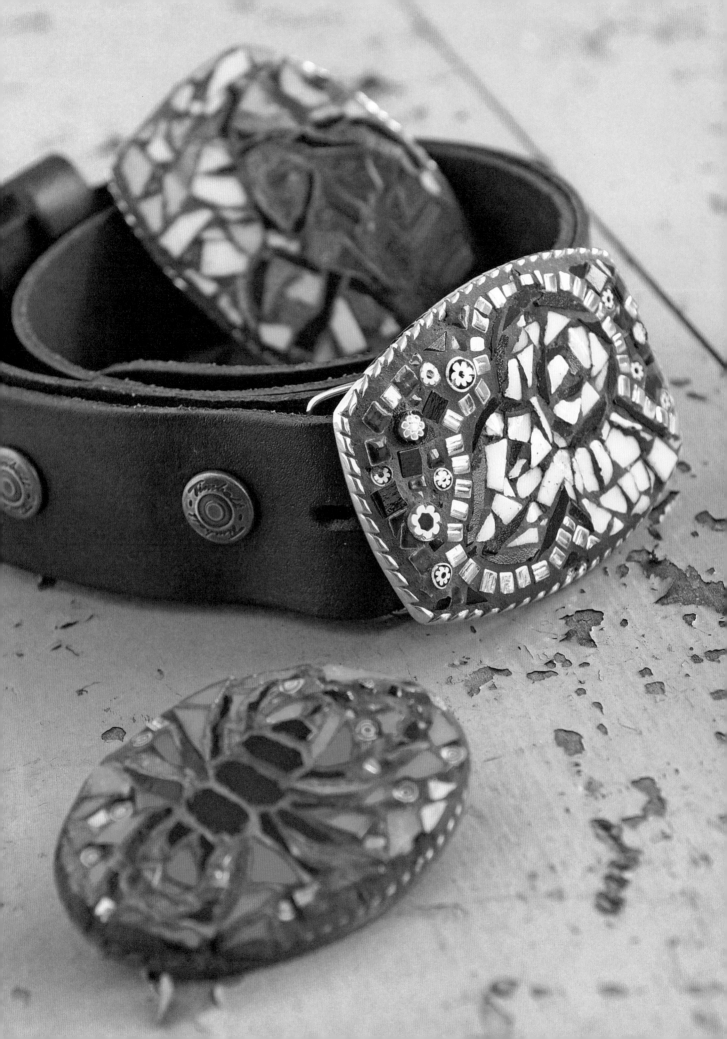

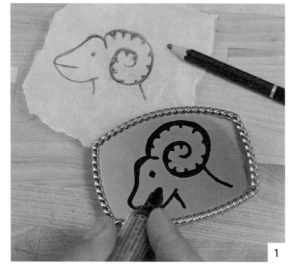
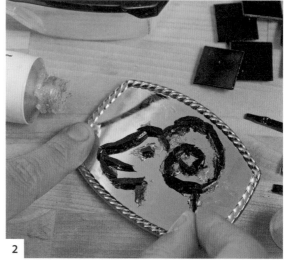
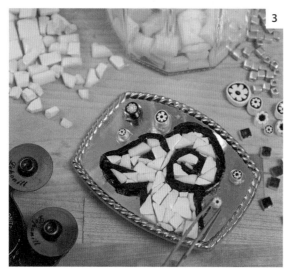
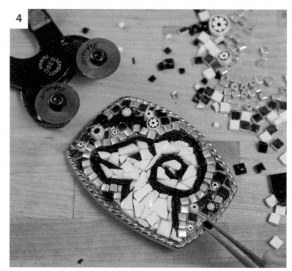

1 **2**

3 **4**

1 Draw the design onto the buckle blank using a permanent marker pen. As the base of the buckle is shiny you will not be able to trace the design onto the surface with a pencil. If you do not feel confident to draw the lines freehand trace the template on page 124, cut out the traced motif and draw around the outside of the design. Fill in the centre lines by hand.

3 Once the outline is finished cut a small piece for the eye and fill in the rest of the head area with a mixture of ceramic and glass white mini tiles. Now glue some millefiori beads around the head, as shown.

2 Cut the 2cm (¾in) black vitreous glass tiles into long, thin strips by dividing the tiles into quarters or sixths (see page 17). Make some thin, pointed strips by cutting the tiles across diagonally, making cuts very close to one another to form fine shards of tile. Use these pieces to tile the outline of the ram's head (see Tip opposite).

4 Tile a row of metallic silver beads around the head to form a halo effect. Tile these metallic beads on their side so that the thread hole is not visible from the top and so that the beads form a continuous line following the contours of the head. Tile the rest of the background with micro black ceramic tiles cut to fit in snugly around the beads.

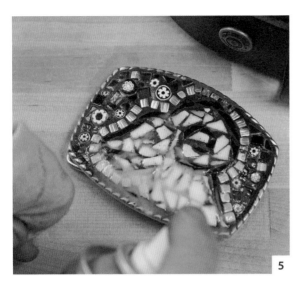

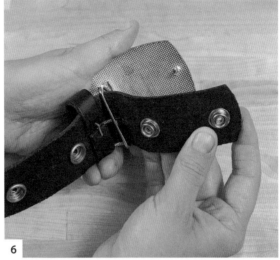

5 Grout the buckle using a black grout (see page 25 for how to grout this buckle step by step). Once the grout is dry use a soft, clean cloth and some household polish to shine the metallic beads and remove any grout 'haze' on the surface.

6 Attach the belt by passing it through the loop at the back of the buckle base and closing the studs around it to secure in place. The buckle is manufactured with a pin that fits into the holes of the belt, so the size can be adjusted.

Tip WHEN USING THIN TILE SHARDS, MAKE SURE THE PIECES HAVE ENOUGH CONTACT AREA WITH THE BASE SO THEY STAY UPRIGHT AND DO NOT TOPPLE OVER IN THE ADHESIVE.

BUTTERFLY BUCKLE

This butterfly design uses glass gem beads and mirror pieces integrated into the wings. Other ideas for buckle designs can include paisley, fleur de lys, damask patterns or Chinese symbols for luck and happiness. The template for this design is on page 124.

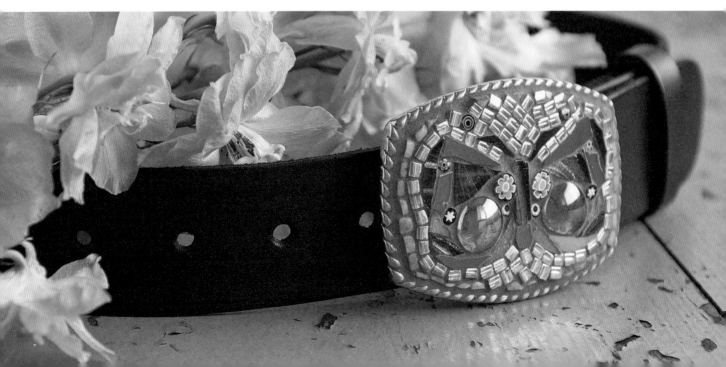

Heraldic Tie Pin and Cuff Links

This stylish tie pin and cuff link set are almost weightless and make a super handmade gift for men of all ages. Tiles with a pewter finish have been used to provide a metallic sheen to the shield's surface and the use of dark brown grout and muted earthy browns, reds and cream colours give the set an authentic aged look that is subtle and discreet. The cuff links measure just 2.5cm (1in) and the tie pin 4 x 6.5cm (1½ x 2½in).

You will need

Piece of 3mm (⅛in) plywood
9 x 9cm (3½ x 3½in)

Ceramic nano tiles
in pewter, dark brown, red, ochre, cream and tan

Nickel-plated tie clip 4cm (1½in) long

2 silver-plated cuff link backs
1cm (⅜in) diameter

PVA (white) adhesive

Brown acrylic paint

Dark brown grout
(see page 24)

Superglue

Making time: 1–3 hours

Drying time: 20 minutes–1½ hours

Weight: tie pin 15g (½oz)
cuff links (pair) 10g (¼oz)

GLAZED CERAMIC NANO TILES ARE THE IDEAL SIZE FOR CREATING GREAT GIFTS FOR THE MEN IN YOUR LIFE, MAKING IT POSSIBLE TO MAINTAIN FINE, DELICATE DETAIL EVEN ON THIS SMALL SCALE.

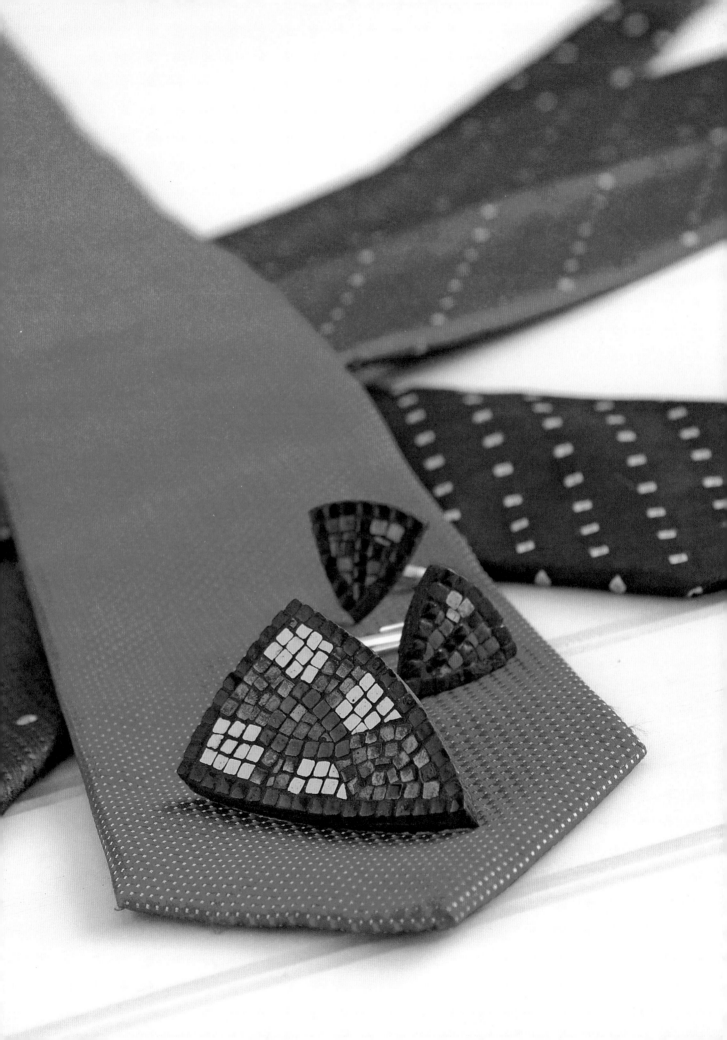

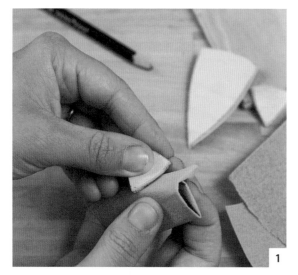

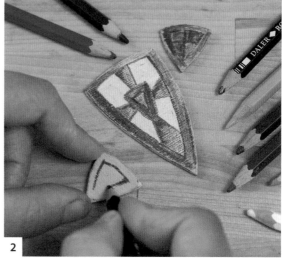

1

2

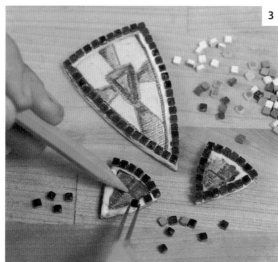

3

1 Using the template on page 115, trace and transfer the tie pin and cuff link shields onto the piece of plywood (see page 110 for tracing technique) and cut out with a scroll saw. Lightly sand around the edge of each shield with a piece of fine-grade sandpaper to remove any splinters or rough edges.

2 Using colouring pencils or wax crayons draw the shield designs onto the plywood shapes, filling in the different shaded areas to use as a guide when tiling.

3 Using the PVA (white) adhesive, spread a row of glue around the outer edge of the shields and start by tiling a row of dark brown tiles all the way around the outsides. Space them evenly making sure that the whole tiles fit exactly and there are no cut tiles. Tweak any tiles that slip out of line back in place with the tip of the tweezers so that the lines are all neat and straight (see also Tip below).

Tip MAKING THE TIE PIN AND CUFF LINKS SIMULTANEOUSLY WILL SAVE TIME WHEN SORTING AND SEPARATING THE TILE COLOURS.

Tip AS THESE PIECES ARE SO LIGHT AND THE TILES SO SMALL YOU MAY FIND IT EASIER TO STEADY THE CUFF LINKS WITH THE TIP OF A PENCIL TO STOP THEM FROM MOVING ACROSS THE TABLE AS YOU APPLY THE TILES.

Medieval Knights

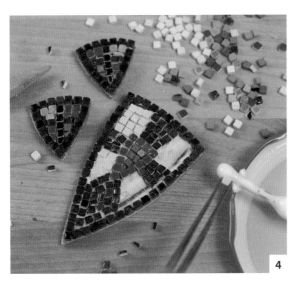

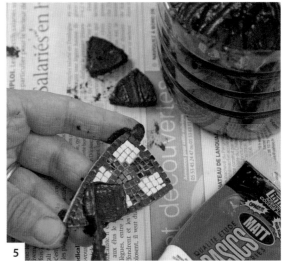

4

5

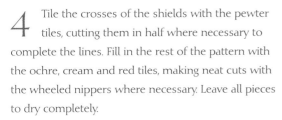

6

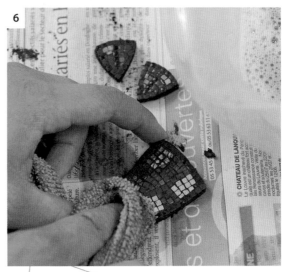

4 Tile the crosses of the shields with the pewter tiles, cutting them in half where necessary to complete the lines. Fill in the rest of the pattern with the ochre, cream and red tiles, making neat cuts with the wheeled nippers where necessary. Leave all pieces to dry completely.

5 Using the dark brown acrylic paint, mix up a small amount of dark brown-coloured grout to a thick, putty-like consistency (see page 24) and spread over the surface of the tiles until they are completely covered. Remember to fill the tiny spaces between the tiles and the wood at the edges too.

6 As the gaps on these pieces are so minute it is possible to remove the excess grout from the surface with a damp cloth after just a few minutes of drying time. Once all the excess grout has been removed, smooth the edges of the shields with the damp cloth and leave to dry completely.

Tip TO AVOID APPLYING TOO MUCH GLUE TO SUCH A SMALL SURFACE, AND TO AVOID COVERING ALREADY TILED AREAS OF THE DESIGN, IT IS EASIER TO PROP A GLUE BRUSH, LOADED WITH ADHESIVE, ON TO THE EDGE OF A JAR LID AND THEN 'BUTTER' THE BOTTOM OF THE TILES. PRESS THE BOTTOM OF THE TILE GENTLY AGAINST THE GLUE, AS SHOWN IN PICTURE 4 ABOVE, AND THEN APPLY TO THE WOOD.

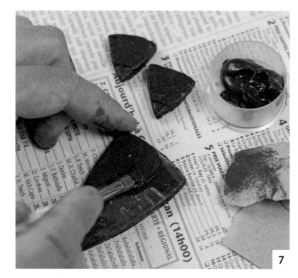

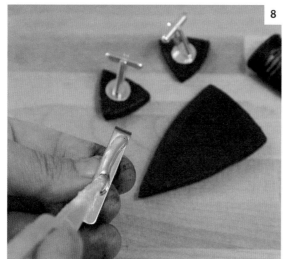

7 If the edges of the shields are still slightly uneven, sand carefully with a piece of fine-grade sandpaper before painting the back of the shields with the same dark brown acrylic paint that you used to colour the grout. Allow to dry completely.

8 Glue the tie clip and cuff link backs centrally to the wood with superglue.

MEDIEVAL KNIGHT TIE RACK

Continuing the medieval theme this tie rack has been transformed into a unique gift by tiling the central wooden support with a knight motif. Taking inspiration from the Bayeaux Tapestry, the design is created with glazed nano ceramic tiles. The central support measures 23cm (9in) tall and 4.5cm (1¾in) wide, with a hanging capacity for 20 ties. The template for this design is on page 115.

 Medieval Knights

GLOSSARY

Adhesive A substance that sticks tiles to their backing. PVA is the most popular choice for indoor mosaics. Other adhesives can be polyurethane, cement or silicon-based glues.

Acrylic paint A water-based artist's paint used to colour grout.

Andamento A Latin term used to describe the direction and 'flow' of the mosaic resulting from the tile placement.

Ceramic tesserae Tiles of fired clay that can be glazed or unglazed.

Direct method A technique of laying the tiles face up directly into their final position (see page 21).

Glass nuggets Glass gems available in a large range of opaque and transparent colours. They can be flattened or spherical and are flat backed so they adhere securely to a background.

Grout A substance that fills the gaps in between the tiles (see page 22).

Indirect or reverse method Tiles are laid onto a temporary surface face down and then flipped into an adhesive bed on the final surface before grouting (see page 21).

Interstices or joint The space or gap between tiles, which provide an important and integral part in the overall finish of the design.

Jewellery findings Components used to create and assemble jewellery.

MDF Medium-density fibreboard used as a base for mosaics, which is best for indoor applications. If used outdoors it must be thoroughly prepared by sealing with a solution of diluted PVA (white) adhesive and yacht varnish.

Micro mosaics Developed in Rome, Italy, from the 16th to 19th century. Micro mosaic-making techniques enabled near perfect reproduction of paintings and became popular for embellishing jewellery and luxury items.

Millefiori Exquisite glass beads made in Italy since the 15th century. Millefiori means 'thousand flowers'.

Mini, micro and nano mosaic tesserae Glass and ceramic tiles manufactured to smaller dimensions for fine detailed mosaic work. Mini tiles are often called 'tiny' in the USA.

Mixtec/Aztec times Period of American/Indian history between the 15th and 16th century, from which examples of mosaic body decoration and accessories have been found.

Nippers Wheeled or 'sidebiter' tungsten carbide-tipped cutters for all types of tile (see page 14).

Opus Latin word for 'work' used to describe the laying of the tessera (see page 20).

Opus classicum This technique combines opus tessellatum with opus vermiculatum.

Opus musivum This opus is created when opus vermiculatum is extended and repeated so that the entire area is filled (see page 20).

Opus paladianum Tiles are laid in an irregular, random pattern, sometimes called 'crazy paving'. It is important to have regular gaps with this opus.

Opus regulatum Tiles laid in a regular grid, both horizontally and vertically. It was a Roman technique and was used to fill in large expanses of background.

Opus tessellatum Tiles are applied in straight rows, horizontally or vertically. This opus results in a 'brick wall' effect.

Opus vermiculatum This opus outlines the shape of the mosaic motif to create a 'halo' or aura effect. Vermis is the Latin word for worm.

Pigment A fine powder used to colour grout.

Polymer clay Sculptable material that can cure at a low temperature. It can also be used to create mosaic tesserae.

Resin tiles Thin synthetic tiles that can be cut with household scissors.

Seed beads Generic term for any small bead; although they are usually rounded in shape.

Tessera An individual tile in a mosaic, usually in the shape of a cube. The plural form is tesserae.

Vitreous glass tesserae Tiles made by pouring molten glass into moulds often with the addition of oxides and mineral salts to produce iridescent, metallic gold veining and marbleized effects. They are made with a rippled underside to aid adhesion.

Templates

The templates you will need for the projects in this book are contained in this section and they have all been reproduced actual size.

TRACING A DESIGN

This example of how to trace a design uses Isis, the winged goddess motif for the jewellery box project on page 44.

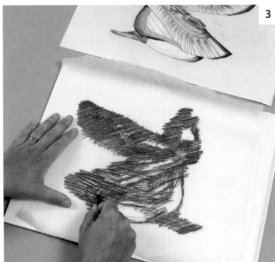

1

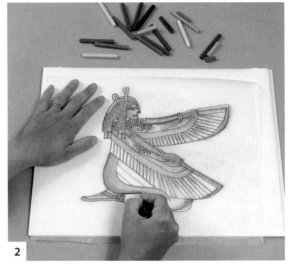

2

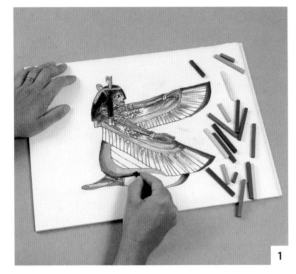

3

1 First, the motif is sketched to size on a sketchpad; you can see that the template shown on page 114 is the sketch equivalent.

2 Trace the sketch or template from the original onto the tracing paper using a thick, soft pencil (a 2B, 4B or 6B is excellent for this purpose).

3 Turn the tracing paper over and apply a thick layer of pencil graphite/lead liberally to the back of the lines by scribbling roughly all over the back of the image.

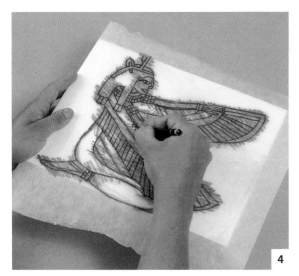

4 **5**

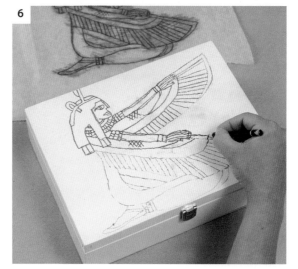

6

4 Place the image right way up on top of a piece of wood (or box in this case) and re-draw the original lines with the pencil. Re-drawing back over the original lines of the motif will transfer the image onto the wood surface ready to tile or cut out with a jigsaw or scroll saw.

5 During the re-drawing process, peel back the tracing paper from time to time to check that you are applying enough pressure to make an impression on the wood surface.

6 Finish off by removing the tracing paper and going over the lines again to make them dark and completely clear.

Tip TO KEEP THE TRACING PAPER IN POSITION WHILST TRACING USE SMALL PIECES OF MASKING TAPE TO HOLD THE EDGES SECURE AND AVOID ACCIDENTAL MOVEMENT.

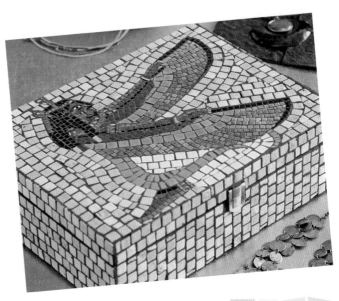

PETITES FLEURS

Round Daisy Ring (page 32)

Daisy Bracelet (page 32)

Iris Bracelet (page 35)

Oval Daisy Ring (page 35)

Magnolia Pendant (page 31)

RITZY AND GLITZY

Mirror Stars Earrings
(page 40)

Magnolia Earrings (page 31)

Mirror Stars Brooch (page 40)

Templates

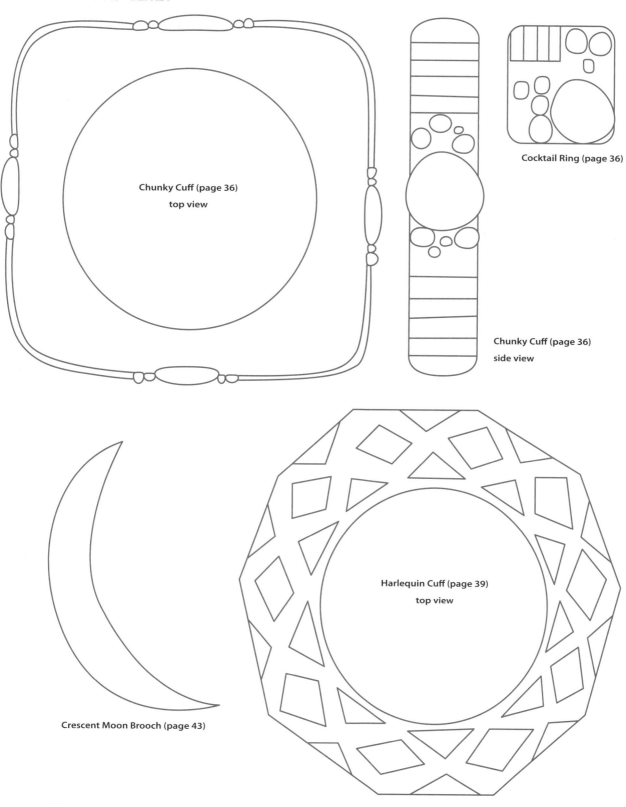

Chunky Cuff (page 36)

top view

Cocktail Ring (page 36)

Chunky Cuff (page 36)

side view

Harlequin Cuff (page 39)

top view

Crescent Moon Brooch (page 43)

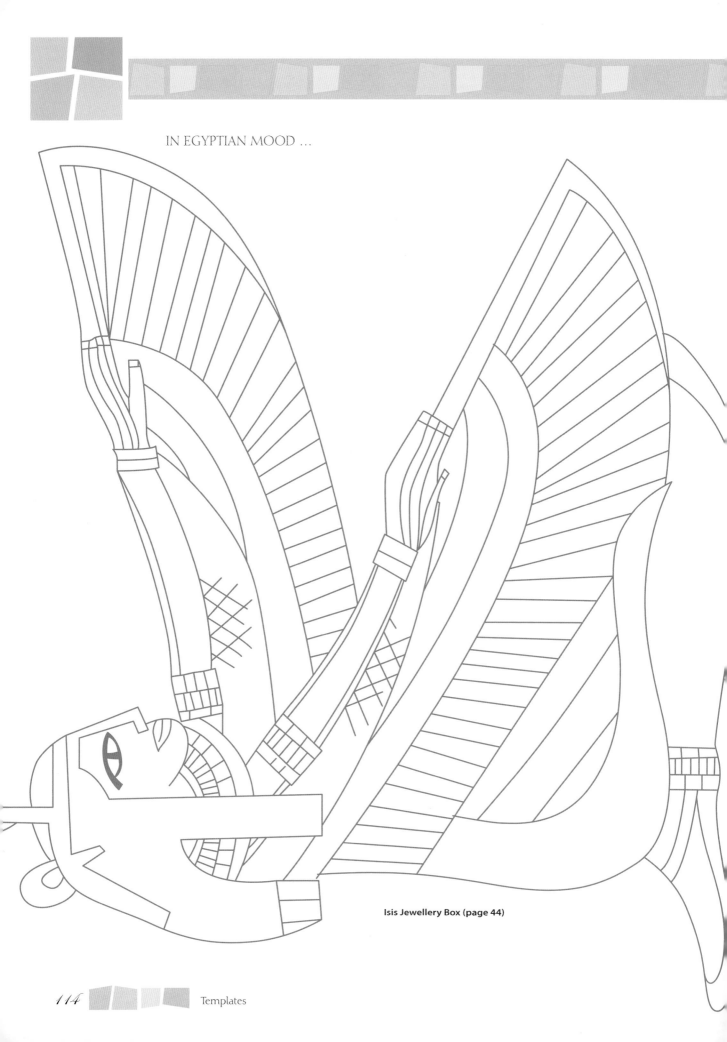

Isis Jewellery Box (page 44)

Templates

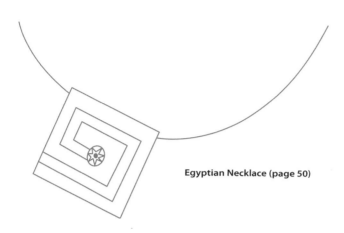

Egyptian Necklace (page 50)

Egyptian Bangle (page 50)

side view

MEDIEVAL
KNIGHTS

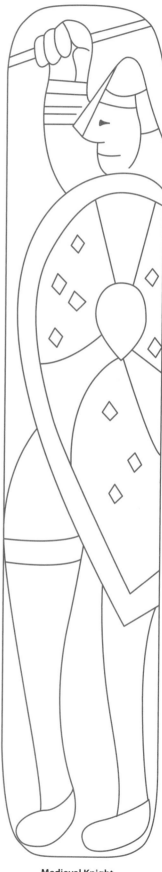

Scarab Trinket Box (page 48)

Heraldic Tie Pin (page 104)

Heraldic Cuff Links (page 104)

Medieval Knight
Tie Rack (page 108)

ART NOUVEAU INSPIRATION

Bijoux Brooch (page 58)

Bijoux Bowl (page 54)

Templates

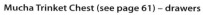

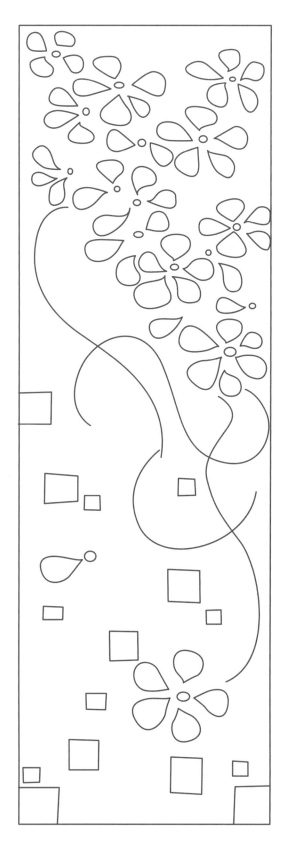
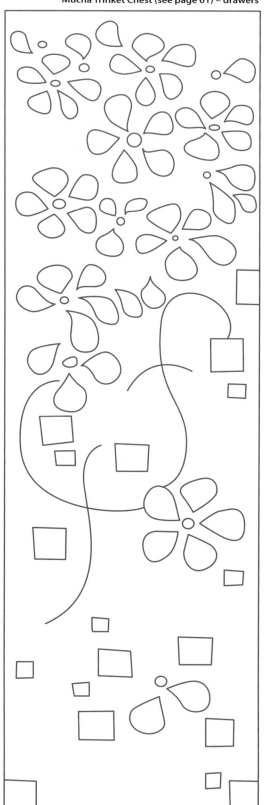

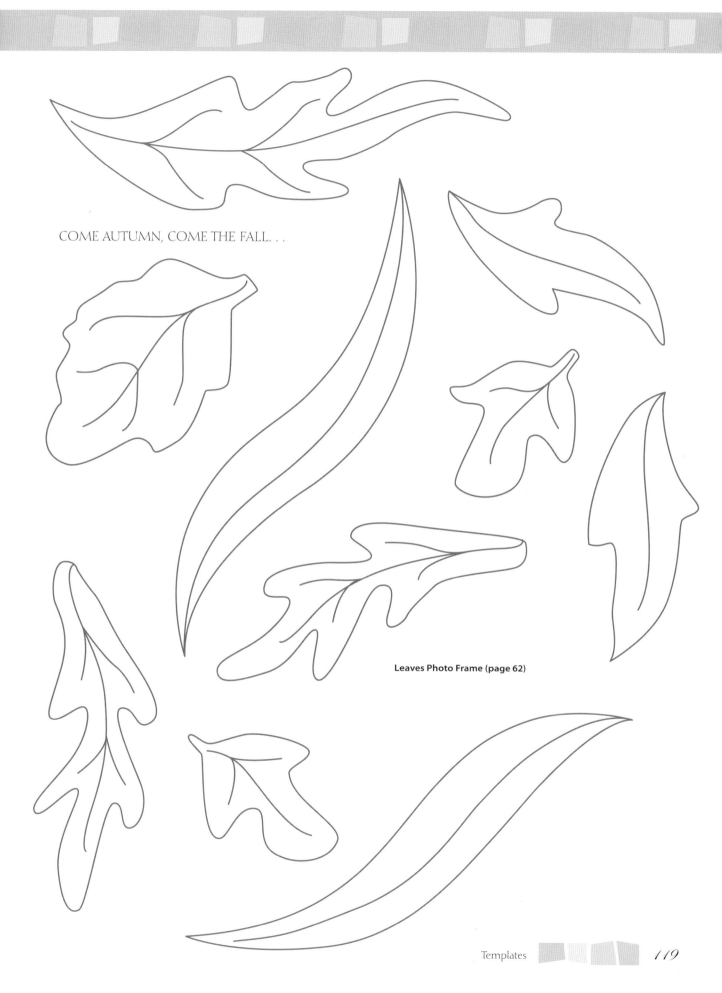

COME AUTUMN, COME THE FALL...

Leaves Photo Frame (page 62)

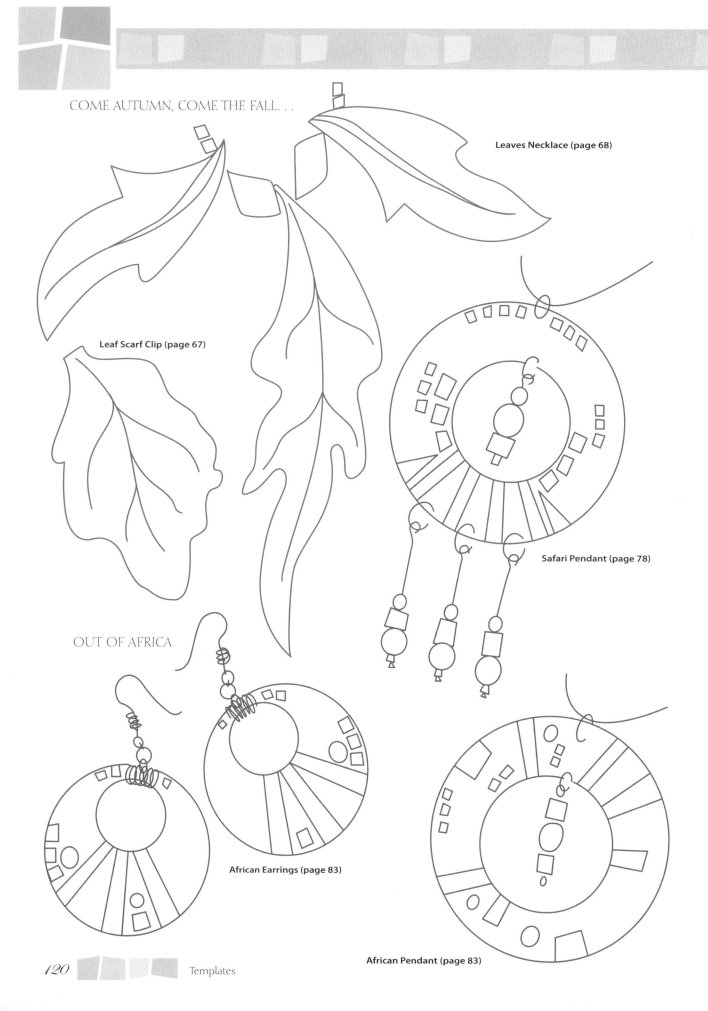

COME AUTUMN, COME THE FALL. . .

Leaves Necklace (page 68)

Leaf Scarf Clip (page 67)

Safari Pendant (page 78)

OUT OF AFRICA

African Earrings (page 83)

African Pendant (page 83)

Templates

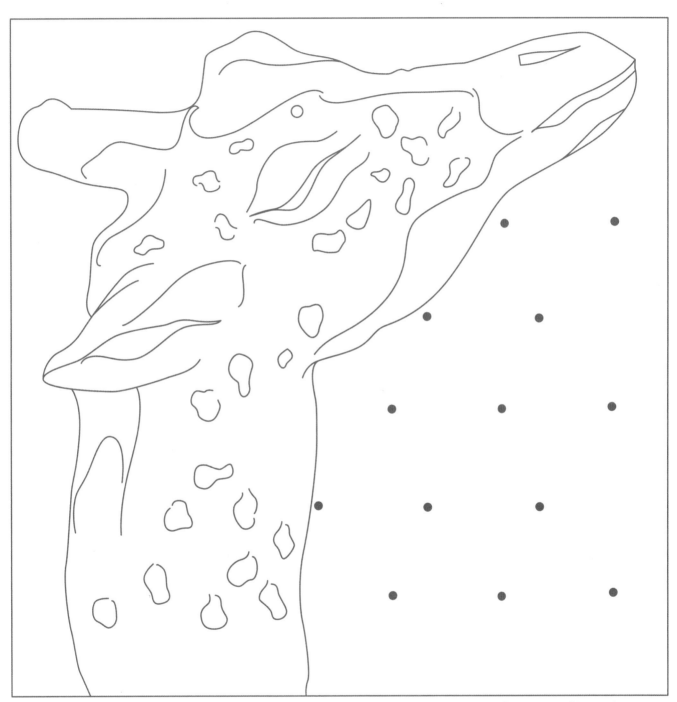

Giraffe Earring Board (page 72)

(the dots show the positions of the eyelets)

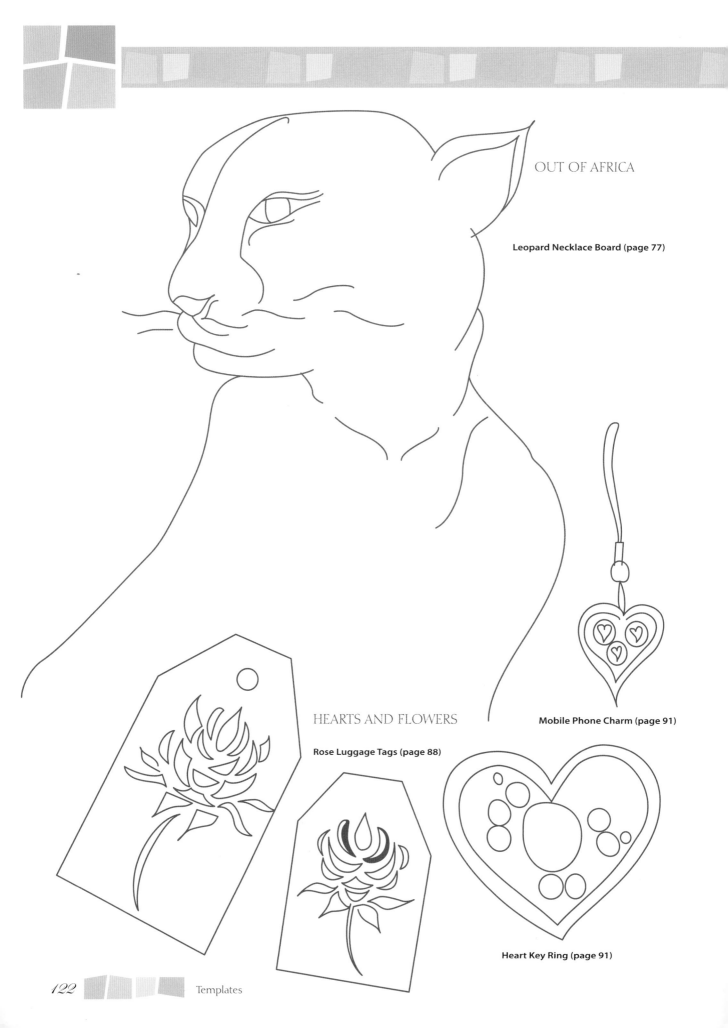

OUT OF AFRICA

Leopard Necklace Board (page 77)

Mobile Phone Charm (page 91)

HEARTS AND FLOWERS

Rose Luggage Tags (page 88)

Heart Key Ring (page 91)

FLORAL TREATS

Floral Lotions Bottle (page 84)

Cotton Wool Pot (page 87)

SUN, SEA AND SAND. . .

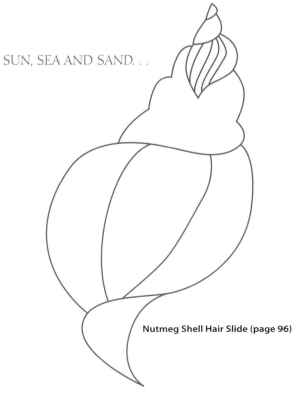

Nutmeg Shell Hair Slide (page 96)

Scallop Shell Sarong Clip (page 92)

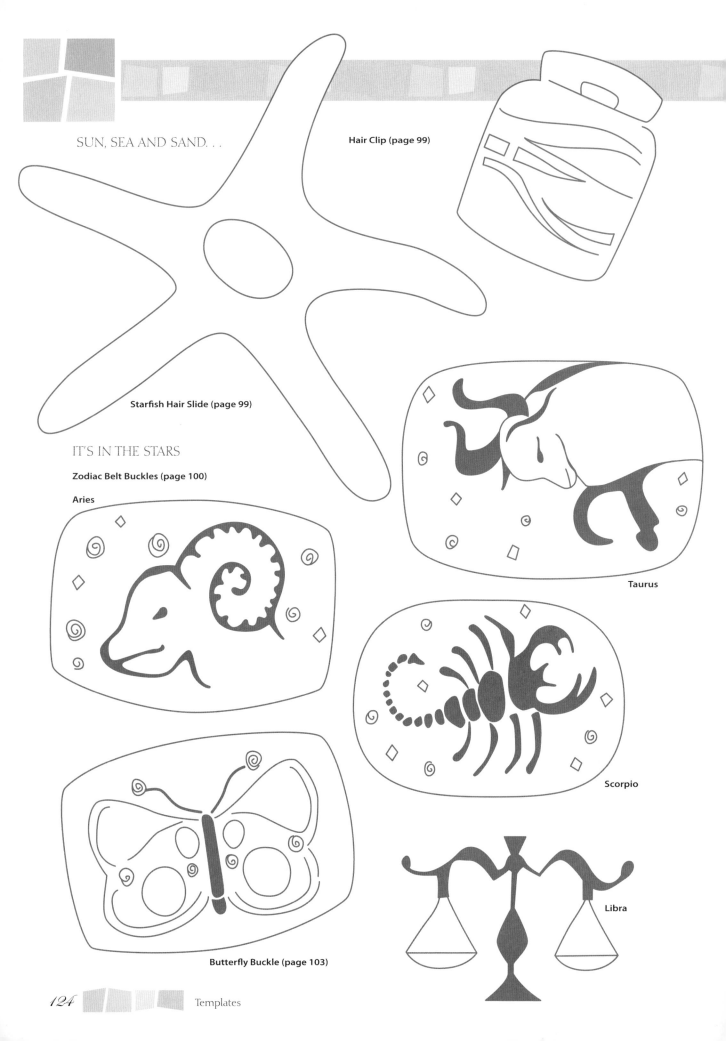

SUN, SEA AND SAND. . .

Hair Clip (page 99)

Starfish Hair Slide (page 99)

IT'S IN THE STARS

Zodiac Belt Buckles (page 100)

Aries

Taurus

Scorpio

Libra

Butterfly Buckle (page 103)

Templates

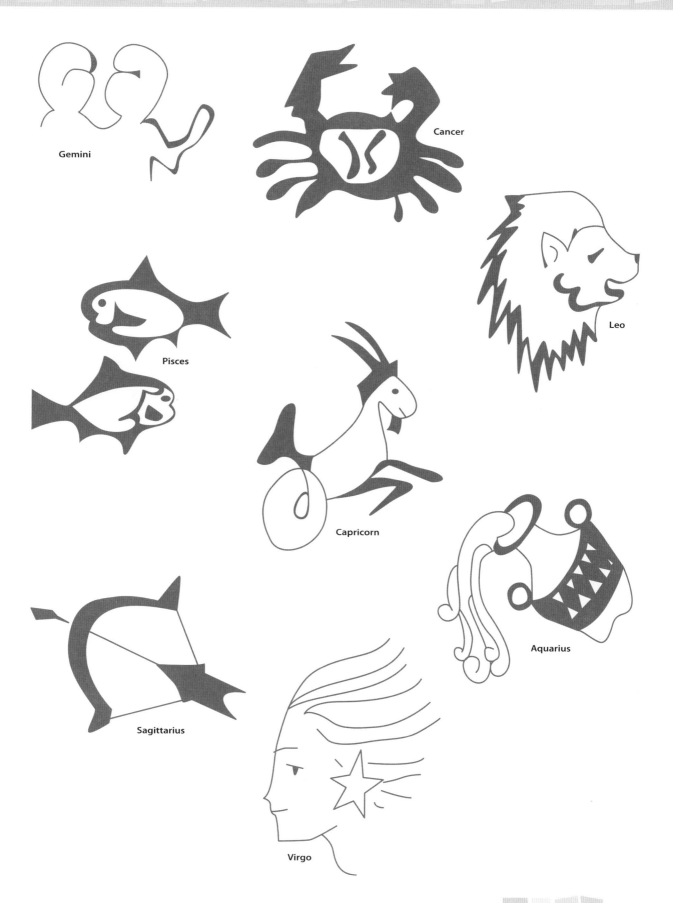

Gemini

Cancer

Leo

Pisces

Capricorn

Aquarius

Sagittarius

Virgo

SUPPLIERS

MOSAIC MATERIALS

UK and International

ELLE-ART MOSAIC & BEADS
46 Victoria Road
Ruislip
Middlesex, HA4 0AG
Tel: 01895 633528
www.elle-art.co.uk/shop

THE CRAFT KIT
Zwarteweg 97, 1431 VK Aalsmeer,
The Netherlands
Tel: +31 297 344 668
www.thecraftkit.com

XINAMARIE MOSAICI
Via Fabio Filzi, 2, 25087
Villa di Saló, Brescia, Italy
Tel: +39-0365-43243
Email: info@xinamarie.com
www.xinamarie.com

KIT CREATION
29 rue de la Resistance, 42000
Saint Etienne
Tel: 04 77 413 296
Fax: 04.77.41.32.96
Email: contact@kit-creation.fr
www.kit-creation.fr
www.witsendmosaic.com

USA

WITSEND MOSAIC
PO Box 914 , 143 N. St
Augustine St, Pulaski, WI 54162
Tel: 1-888-494-8736
or (920) 822-7666
Email: service@
witsendmosaic.com

MOSAIC ART SUPPLY
743 Edgewood Ave,
Atlanta, GA 30307
Tel: 404-522-7221
Email: inspire@
mosaicartsupply.com
www.mosaicartsupply.com

JEWELLERY FINDINGS

UK and International

**THE BEAD SHOP
(NOTTINGHAM) LIMITED**
7 Market Street,
Nottingham, NG1 6HY, UK
Tel: +44 (0)115 9588899
Fax: +44(0)115 9588903
General Enquiries:
info@mailorder-beads.co.uk
Order Enquiries:
orders@mailorder-beads.co.uk

THE BUCKLE SHOP
www.buckle-shop.com
For belt buckle blanks

USA

JEWELRY SUPPLY
Roseville, CA 95678
Tel: Customer Care (916)780-9610
Fax: (916) 780-9617
Toll-Free: 866-380-7464 (US only)
Email: help@jewelrysupply.com
www.jewelrysupply.com

SITES OF INTEREST

**AZTEC/ MIXTEC TURQUOISE
MOSAICS**
The British Museum,
Great Russell Street,
London WC1B 3DG
www.britishmuseum.org

ITALIAN MICRO MOSAICS
The Gilbert Collection Trust,
Somerset House, Strand,
London WC2R 1LA
www.gilbert-collection.org.uk

ABOUT THE AUTHOR

Angie Weston trained as a fine art painter in the 1980s and is now a mosaic artist, specializing in practical pieces for everyday use in the home and garden. She exhibits in London and south east England, and runs residential mosaic courses from her studio in France. You can visit her website at www.mosaic-courses.com to see more of her work and for details of courses. Angie's first book for David & Charles, *Mosaic Magic*, was published in 2008.

ACKNOWLEDGMENTS

My biggest thanks go to Ginny Chapman for all her support, brilliant photography and for helping me keep a positive perspective on it all. To Chloe Bentley, my friend and studio assistant, for all the laughs and never complaining about the endless tile sorting and tidying.

To Jane Trollope, Emily Rae, Sarah Underhill, Jo Richardson and Lin Clements for all your contributions, help and guidance.

Finally, to Pete, Pandora and Indra who make it all worth it.

INDEX